ART WITH A DIFFERENCE

ART WITH A DIFFERENCE
Looking at Difficult and Unfamiliar Art

Leonard Diepeveen
Dalhousie University

Timothy Van Laar
University of Illinois

Boston Burr Ridge, IL Dubuque, IA Madison, WI New York San Francisco St. Louis
Bangkok Bogotá Caracas Kuala Lumpur Lisbon London Madrid Mexico City
Milan Montreal New Delhi Santiago Seoul Singapore Sydney Taipei Toronto

McGraw-Hill Higher Education

A Division of The McGraw-Hill Companies

ART WITH A DIFFERENCE: LOOKING AT DIFFICULT AND UNFAMILIAR ART

Published by McGraw-Hill, a business unit of The McGraw-Hill Companies, Inc. 1221 Avenue of the Americas, New York, NY, 10020. Copyright © 2001 by The McGraw-Hill Companies, Inc. All rights reserved. No part of this publication may be reproduced or distributed in any form or by any means, or stored in a database or retrieval system, without the prior written consent of The McGraw-Hill Companies, Inc., including, but not limited to, in any network or other electronic storage or transmission, or broadcast for distance learning. Some ancillaries, including electronic and print components, may not be available to customers outside the United States.

This book is printed on acid-free paper.

5 6 7 8 9 0 DOC/DOC 9 8 7 6 5

ISBN 1-55934-930-1

Sponsoring editor, Janet M. Beatty; *production editor,* Carla WShite Kirschenbaum; *manuscript editor,* Andrea McCarrick; *text and cover designer,* Susan Breitbard; *art editor,* Rennie Evans; *manufacturing manager,* Randy Hurst; *photo researcher,* Brian Pecko. The text was set in 10/12 Sabon by Thompson Type and printed on 50# Somerset Matte by R. R. Donnelly & Sons.

Cover image: B. Adilon. Photo courtesy of Sean Kelly Gallery.

Text Credit: p. 20, From *Inventing the Louvre: Art, Politics, and the Origins of the Modern Museum in Eighteenth-Century Paris* by Andrew McClellan, (Berkeley: University of California Press, 1999). With permission from the author.

Library of Congress Cataloging-in-Publication Data

Diepeveen, Leonard,
 Art with a difference : looking at difficult and unfamiliar art / Leonard Diepeveen, Timothy Van Laar.
 p. cm.
 Includes bibliographical references and index.
 ISBN 1-55934-930-1
 1. Art appreciation—Study and teaching (Higher) I. Van Laar, Timothy. II. Title.
N345.D54 2000
701'.18—dc21
 00-025676

www.mhhe.com

For Benjamin and Annelies
For Elise and Jacob

CONTENTS

CHAPTER 4 **ART AND DIFFICULTY**
Foucault's Nightmare 93

PREFACE

Art with a Difference: Looking at Difficult and Unfamiliar Art was written as a supplementary text for undergraduate art courses. This text will fill an important role in these classes, for while it is certainly important that students learn to understand and interpret art through the traditional approaches of art appreciation and art history courses, we live in a time that is increasingly critical of the very assumptions that underlie Western art, and this book examines some of the issues central to these critical discussions. *Art with a Difference* introduces topics that are typically overlooked or underrepresented in standard art texts: the role of the museum in creating the canon of high art, the most useful ways to understand art of other cultures and outsider art, and the process and strategies necessary to interpret difficult art, especially contemporary art. These are issues that dominate recent art criticism, art theory, art politics, and the structure of art institutions. And as our first and last chapters particularly demonstrate, these issues are also central to students' experience of art.

Art with a Difference is written not for critics but for college students and general readers; it does not require much prior knowledge of art. It assumes that its readers have some current involvement and interest in art (such as taking an art appreciation course), but otherwise it assumes nothing more than what a well-informed person would know from newspapers, magazines, occasional PBS programs, and general education. It is intended as a supplementary text that goes into detail about a few current issues, leaving the tasks of art history surveys and introductions to formal analysis to the introductory art texts.

Some important principles connect this book's diverse chapters. We think a good way for students to gain entry into the issues of this book and of the art world is by working with the idea of unfamiliarity, what some aestheticians call *estrangement.* We do not mean to imply that all of the examples in this book are equally unfamiliar to each individual student: there are undoubtedly students, for example, for whom African art has been an important part of their lives. In a sense, this book is not about its major examples (such as the art of other cultures); it is about the *process* of encountering unfamiliar art. There is no person to whom all art is familiar and easy, and this book gives some general principles on how to approach such art. In the first chapter, we take the ordinary experience of visiting a museum and make it strange and unfamiliar. The museum is a good place to begin because it is often the first place many students encounter both the institution of high art and the art that they initially find unfamiliar and difficult.

In the remaining three chapters, we reverse that process by making familiar what at first seems strange: in Chapter 2 we look at art of other cultures and how Western art has tried to make itself comfortable with it; in Chapter 3 we examine the strangeness of outsider art from within Western culture; and in Chapter 4 we explore the anxiety that results from difficult, unfamiliar art, particularly contemporary art.

Power is another of this book's connecting threads. In Chapter 1 we look at the power of the museum in defining the canon. In Chapters 2 and 3 we discuss the issue of Otherness—that is, the power of Western mainstream art culture over outsider art as well as the power Western culture exerts over other cultures through looting, co-opting, defining, and decontextualizing objects of other cultures. In Chapter 4 we examine the power that difficult art has over us.

A final connecting thread is the concept of purity in relation to art. In many places this book argues that dealing with art can be a messy, impure experience in which it is often impossible to get things exactly right by following a single agenda. In the first chapter we discuss how the art museum is not and cannot be just a place where the "best" art of a culture is housed; it is an institution full of contradictory impulses, including tensions among national interests, the interests of education, and commercial interests. In the next chapter we see how approaches to other cultures and their art are equally messy, for it is problematic to look at them in either the purely formal way of Western art or in exactly the way that their original makers saw them. In discussing outsider art in Chapter 3, we examine how the art world's typically ironic use of outsider art is an ethical problem and complicates our enjoyment of it. Finally, in Chapter 4, we look at how difficult art often disrupts the purity of aesthetic appreciation by destabilizing the viewer's experience. Our interaction with art, this book argues, is not an uncomplicated, unproblematic experience.

Art with a Difference begins where most people *are* in relationship to art—occasional visitors to art museums. Almost everyone has been to an art museum, if only on a school trip. This is commonly the first and only serious exposure to art many people have. Thus, the text begins by using the museum—the aspect of art that students know or think they are familiar with—to draw the reader into the big questions. What kinds of art are important? Why are some artworks considered important and not others? Who decides what is important, anyway? While addressing these questions, the book engages in a critique of the museum itself, a subject of current interest in the art world.

Chapter 2 extends logically away from the Western museum to discuss problems inherent in viewing and portraying the art of other cultures, an issue with which museums are in constant struggle. The chapter addresses some of the problems of looking at the art of other cultures, and it asks questions about notions of universal values in art.

The third chapter looks within Western culture at what has been termed *outsider art*—the art of the mentally ill, naive art, and folk art—examining the relationship between how Western culture defines its outsider art and how it defines the art of other cultures. Outsider art has been the subject of numerous exhibitions in major museums and galleries throughout the country, and many

artists, such as Jean Dubuffet, have been highly influenced by its study. But the designation *outsider art* is problematic, and thus this chapter asks such questions as: What is pure and authentic outsider art, and who decides? Or is it even useful to ask such a question?

The final chapter of the book addresses an experience central to many students' exposure to art: the anxiety one feels in the presence of artworks that one doesn't understand, such as a Dogon door, the outsider artist Henry Darger's obsessed narratives, or an Ann Hamilton installation. Perhaps the most pressing questions students have are, Why is so much contemporary art difficult to understand? Do artists intentionally make art difficult? Why does difficult art make me uncomfortable? Will work that is difficult to me right now always be difficult? Is difficulty central to modern art and the experience of art of other cultures, or is it a by-product? This chapter seeks to clarify these issues by examining different ways that artworks can be difficult, by examining how difficulty becomes a positive value, and by discussing elitism as it relates to difficult art.

Art with a Difference introduces students to some of the big issues that drive the current art world and form part of the context of high art. This book not only discusses some commonly held ideas about art (that art, for example, is primarily about originality, beauty, and progress) but also introduces other aspects of the art experience that are less frequently examined: anxiety, innocence and authenticity, the relationship of art to national and commercial interests, how art deals with social differences, and how Western art has interacted with the art of other cultures. As such, *Art with a Difference* focuses on some of the contentious areas in the art world, areas that are usually only tangentially addressed in standard art textbooks.

We would like to thank numerous colleagues and students who have responded to parts of this manuscript over the past few years, particularly students at the University of Illinois at Urbana-Champaign and the Nova Scotia College of Art and Design. In addition, we would like to thank colleagues and students at Dalhousie University, Grand Valley State University, Calvin College, and Indiana University Northwest. The Social Sciences and Humanities Research Council of Canada provided research funds to complete part of this manuscript. In addition, we have received much assistance from the staff at the Ricker Library of the University of Illinois and from Bruce Barber and Dave Klamen. We would also like to thank those who read the manuscript for Mayfield: Betty Disney, Cypress College; Marie T. Cochran, University of Georgia; Mary F. Francey, University of Utah; Dawn Perlmutter, Cheyney University of Pennsylvania; Jean Robertson, Indiana University—Purdue University Indianapolis; and Jan Newstrom Thompson, San Jose State University. The editorial staff at Mayfield Publishing Company has been unfailingly helpful and attentive: Carla Kirschenbaum, Senior Production Editor; Marty Granahan, permissions editor; Andrea McCarrick, copyeditor; and Brian Pecko, our tireless photo researcher. Finally, we would like to thank our Sponsoring Editor Jan Beatty for her help in initiating this project, her good humor, and her patient advice.

ART MUSEUMS
Organizers of Culture

Few things seem more placid than a Sunday afternoon in an art museum, where one can relax while drifting past Monet's water lilies. But although a trip to a museum may capture such a mood, the museum is not just a serene place for **aesthetic contemplation**—and was never completely designed to be one. The museum is more active and conflicted than that; in fact, it makes complicated statements that struggle with each other. For example, although the museum appears to be a neutral container of great art, it engages in more partisan activities. It can celebrate national or civic identities, memorialize personal wealth, organize art objects in definite hierarchies, or hearken back to lost empires. Beneath its placid surfaces, the art museum is a place of complexity, where the interests of donors, national identity, and aesthetic contemplation sometimes cooperate and sometimes conflict.

As we will demonstrate in this chapter, the forms of the museum's differing agendas are predictable and recurrent, and they also have an impact on the art contained within. Viewers may look past these things, but the museum's internal complications affect what the displayed objects *mean*. Part of what Rembrandt's *Night Watch* means has to do with where it is shown, what it is shown with, who takes care of it, who comes to see it—and who doesn't.

Later in this chapter we will discuss exceptions, but for the greater part of this chapter we will look at what is typical about art museums visited by the general public. In doing so, we will generalize and articulate the **conventions** of museum architecture, exhibition, collecting, and organization. But in our describing these conventions we don't mean to argue that these conventions necessarily make the museum suspect. Conventions are inescapable, and it's useful at times to examine aspects of the art museum that we usually look right past. There are things other than aesthetic contemplation going on in a museum, things that help to explain what art means in Western culture.

The Remarkable Uniformity of Museums

Although there are significant recent exceptions to the rule, what people see when they go to a museum is strikingly consistent. Again and again, they see buildings in a neoclassical style, buildings made of stone, with a rigorous symmetry regulating their appearance. At their entrances, large pillars support imposing triangular pediments. These architectural elements have a clear historical reference—ancient Greece—and can also be found in such buildings as banks and state capitols. The messages this kind of architecture conveys are prestige, stability, and grandeur.

Even departures from this norm consciously echo it; **modernist** buildings use large planes of stone or poured concrete to dub that same geometric stability and grandeur on to the twentieth century. The same architectural language appears everywhere: the columns and enormous staircase of New York's Metropolitan Museum, the inverted pyramid of the Whitney, and the classicism of the Art Institute of Chicago and the New Orleans Museum of Art—all these suggest power, permanence, glory (Figure 1.1).

Surrounding the building itself are often neatly clipped, parklike grounds that separate the museum from the city in the same way that palace grounds intentionally delineate royal estates. The museum's grounds move it away and set it off from the city's conflict, competition, violence. This is not a hockey arena.

But the museum is not completely removed from the values of the city. Lining the street in front of the museum are large banners, which in turn are dwarfed by massive banners affixed to the museum's facade. There is nothing modest about this display; it is a spectacle. And as with the Academy Awards and the Super Bowl, sometimes the grandeur has an overtone of hype to it. The banners themselves hawk the name of the current blockbuster show: "Treasures of King Tut," "Treasures of the Vatican," or "Treasures of English Country Homes." Or the banners may contain a single magnetic surname: "Monet," "Degas," "Picasso."

Engraved on brass plaques directly inside the massive brass and glass doors are the names of the museum's major donors and trustees. To reach the ticket counter you must pass the information desk, which doubles as a membership application center, where memberships are rewarded with such gifts as totebags, T-shirts, and coffee mugs. Upon purchasing a ticket, you receive a map to the collection and a little round disk (a different color every day) that can be clipped to your lapel.

Then you climb the worn, grand marble staircase. Inside the galleries, the sound level drops dramatically. It is the hush of churches and libraries, and it makes you peculiarly aware of how your steps echo between the highly polished hardwood or marble floors and the high ceilings. (Public buildings always echo. It's a grandeur thing.) If you speak, you speak in low tones.

The environment is thoughtfully controlled. The walls are freshly painted, often white. The lighting system is subtle and computerized. You feel the air conditioning and see the vibration and humidity recorders and controls in their neat Plexiglas boxes. The artworks themselves are accompanied by signs that

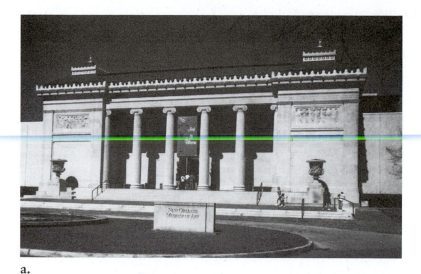

a.

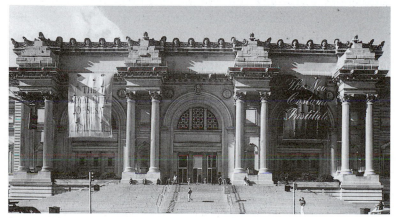

b.

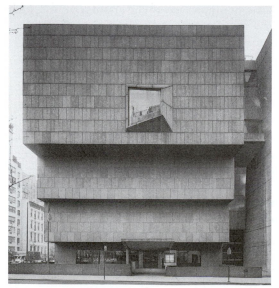

c.

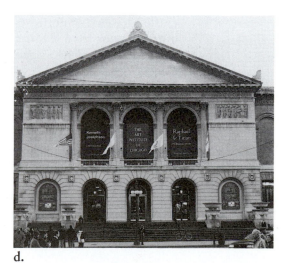

d.

Figure 1.1 Examples of museum architectural styles: (**a**) the New Orleans Museum of Art (photo courtesy of the author); (**b**) The Metropolitan Museum of Art (© Peter Mauss/Esto); (**c**) The Whitney Museum (© Peter Mauss/Esto); (**d**) and The Art Institute of Chicago (photo courtesy of the author).

forbid flash photography and by tiny descriptive labels that you have to stoop to read. Many of the works are set in expensive and ornate frames. In addition to these aids to your viewing pleasure is a lot of discreetly placed security, such as alarms, cameras, vitrines (sealed display cases), ropes, warning plaques, and stoic, unsmiling guards with thick-soled shoes and very good posture (Figure 1.2).

You get mixed signals on how to move among these works. Frequently the galleries are arranged in labyrinthine patterns that apparently defy logic, demand backtracking, and frustrate the systematic and efficient viewer. Without a map, how do you get from Giotto to Titian? (For blockbuster shows, however, where crowds are expected, a clear directional flow pattern is mapped out, and viewers are nudged along by the crowd behind them.) The maze through which you move is illustrated in the museum map, which reveals an odd variety of rooms (Figure 1.3).

The galleries are not all of one kind or size. Some galleries are historically authentic reconstructions of anything from a Frank Lloyd Wright living room to a medieval chapel to an Egyptian tomb. Some galleries are named after wealthy donors or their collections. Some are big spaces with vaulted ceilings and skylights, and others are small, cozy rooms complete with domestic furniture that people, for good curatorial reasons, aren't allowed to sit on. And some galleries are equipped with ten-foot-high partitions that can be rearranged easily to accommodate temporary exhibitions. Often, connecting hallways are also used as gallery space, but they more typically show objects of lesser worth and smaller scale. Through the windows of the museum you get a view of the sculpture garden.

There are also various spaces within a museum that are not devoted to showing art. There are education spaces, such as an auditorium and a room for children's hands-on activities. A museum's reception space (usually a central lobby) can be rented and served by the museum's catering service. A cloak room is available for people to check their large bags and umbrellas. There are also restrooms, although these are often difficult to find. The gift shop, which can be visited without going through the ticket booth, is next to the grand staircase. For sale in the gift shop are art catalogues and art-theory and coffee-table books; postcards, posters, and slides of the museum's collections; coffee mugs; T-shirts; crafted jewelry; imported tribal works; and Bauhaus teapots. And, of course, every museum has a restaurant with good coffee and stylish steel chairs.

An interesting conglomeration of people move through the museum. Docents (volunteer museum guides) explain art to groups of senior citizens who carry along folding camp stools (Figure 1.4). School groups, trying hard not to make noise, jostle through the galleries. Other people, wearing headphones, drift along in the world of the audio tour, narrated by Leonard Nimoy or Charlton Heston. And still other individuals are in a world of their own. All are surveyed by the weary eyes of the immobile guards. Speaking rarely, and in hushed tones, the visitors move in an elegant dance. One thing they *never* do in this dance, though, is touch their partner. Artworks are seen, not felt. Viewers step forward and bob to read the plaque, move back one or two steps to take in the whole painting, and, with perhaps a slight, sensitive glance back, glide on to the next work.

Figure 1.2 Guard, The Art Institute of Chicago. (Photo courtesy of the author.)

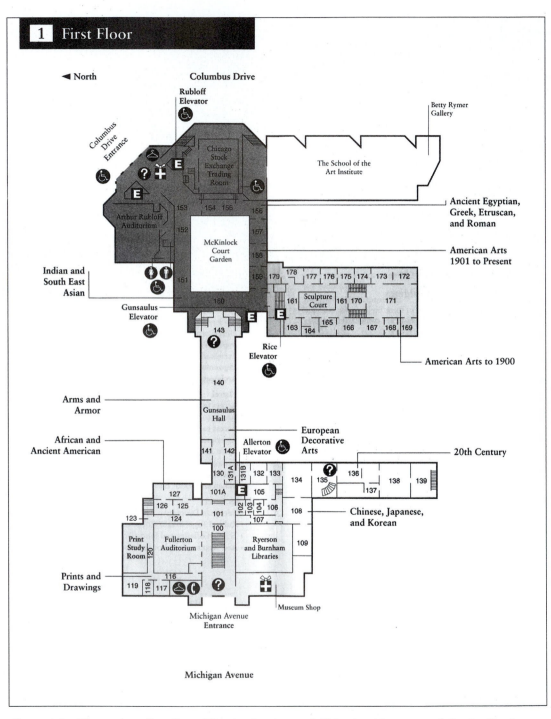

Figure 1.3 Floor plan, first floor, The Art Institute of Chicago. (Courtesy of the Art Institute of Chicago.)

Figure 1.4 Docent with museum visitors, The Art Institute of Chicago. (Photo courtesy of the author.)

Art museums also seem consistent about what is *not* seen. Some things are intentionally unobtrusive. The administrative offices, for example, are not apparent to the average visitor, and neither are the conservation labs, where work is restored and repaired. The workshop where frames, pedestals, and shipping crates are built is not visible, and neither are the vaults that store the objects not on display.

Some people, too, are missing. There is no demographically proportionate representation among the visitors: there are few poor people or ethnic, religious, and racial minorities. For all their talk about being inclusive (and it's more than just talk), museums struggle to attract the poor and minorities.

Further, some types of work are not a big part of the typical art museum: anonymous work after the Renaissance; work by women prior to the late twentieth century; and work of minorities, except perhaps as anonymous representatives of their non-Western countries of origin (for example, tribal art of central Africa). The big comprehensive museums display a lot of oil paintings but not much work that isn't portable. One doesn't see ephemeral work, work that isn't designed to be permanent. And if they are shown, mass-produced work and craft (including artifacts from pop culture) are not given pride of place.

And, of course, in addition to the things they hide or display, art museums make overt statements about what they are doing. The Philadelphia Museum of Art gives as its mission statement:

> The Philadelphia Museum of Art—in partnership with the city, the region, and art museums around the globe—seeks to preserve, enhance, interpret, and extend the reach of its great collections in particular, and the visual arts in general, to an increasing and increasingly diverse audience as a source of delight, illumination, and lifelong learning."[1]

While the Philadelphia Museum concisely indicates that it intends to give pleasure as well as to educate and reach a more diverse audience than it has in the past, other museums are more exuberant about their abilities and qualities than this. On the Metropolitan Museum's website, director Philippe de Montebello makes the following New York–sized claims about his institution:

> The Metropolitan is today a collection of museums—a vast storehouse of knowledge where nearly three million works of art are held for study as well as for display. Indeed, the strength of the Met is that under one roof it provides an almost infinite number of options for many rewarding visits. These can take an infinite number of forms, from random wanderings to planned itineraries, from an in-depth study of a single gallery or exhibition to the exploration of several different cultures or periods.
>
> The Met is a universal museum: every category of art in every known medium from every part of the world during every epoch of recorded time is represented here and thus available for contemplation or study—not in

[1]Philadelphia Museum of Art, 20 June 1999 <http://www.philamuseum.org/information/>.

isolation but in comparison with other times, other cultures, and other media.

If pleasure and instruction are derived from a Museum visit, as we would wish, it is because the ordering and presentation of all aspects of the collections have been continually informed by the knowledge, intelligence, and sensitivity of a superb—indeed unsurpassed—staff of museum professionals. These remarkable men and women, no less than the collections, are what make the Metropolitan the great institution that it is.[2]

(Despite the undeniable truth of these claims, it should be pointed out that one of these "superb—indeed unsurpassed" staff people wrote this.)

Museums, then, in their architecture, presentation, staff, and statements about themselves, are remarkably uniform places, places that assert values. Further, whatever the values of the museum are, they are articulated by the museum building itself. From the heft of its columns to the texture of its materials, the museum's architecture is designed to connote grandness, permanence, power. And with its security guards and systems, the museum efficiently protects what it contains. From its parklike grounds to its hidden washrooms, the museum is designed to be a place removed from the strife of the ordinary world, a place of leisurely contemplation.

Knowing the conventions that structure many museums, it is tempting to be cynical about how they operate. But conventions aren't necessarily illegitimate. The fact that so many art museums are grand, impressive places is because Western cultures generally concur that these buildings contain important things. Further, given the structure of contemporary society, museums need to raise money if they are to continue to exist. Gift shops, therefore, are necessary, and they meet people's desires for quality books, reproductions, and well-designed objects. And it's not just about money. Blockbuster shows not only create revenue, they make the bodies of works by important artists available to viewers who otherwise would never have access to these works. Moreover, museums' security systems, which initially may seem authoritarian, are also essential. They protect works that are seen by thousands of people everyday from theft and vandalism, which are big problems in the art world.

So, it's not surprising that even little details about museums reveal a lot about how art functions in Western society. For example, a museum's tax-exempt status and receipt of government grants reveal a belief that art should be available to everyone. Great art, apparently, belongs to the whole culture. Further, the stress on education in a museum—undertaken by docents, audio tours, lecture halls, and the bookshop—arises from a belief that art can improve people. And these kinds of underlying beliefs are inescapable. *All* art is mediated by values arising from its culture and from its immediate context. Art never is pure art; it is always shaped by its context.

[2]Metropolitan Museum of Art, "The Met and the New Millenium," 8 Jan. 1998 <http://www.metmuseum.org/htmlfile/bullet/mill.html>.

The Museum as an Organizer of Culture

How a museum organizes its collection is a central way of articulating its values. The museum is an *organizer* of culture, and like all organizations, it has its quirks. In his short story "The Analytical Language of John Wilkins," the Argentinean author Jorge Luis Borges explores the arbitrariness of many organizations. Borges cites "a certain Chinese encyclopedia" entitled *Celestial Emporium of Benevolent Knowledge.* In that work, Borges claims, the category *animals* is divided as follows:

> (a) those that belong to the Emperor, (b) embalmed ones, (c) those that are trained, (d) suckling pigs, (e) mermaids, (f) fabulous ones, (g) stray dogs, (h) those that are included in this classification, (i) those that tremble as if they were mad, (j) innumerable ones, (k) those drawn with a very fine camel's hair brush, (l) others, (m) those that have just broken a flower vase, (n) those that resemble flies from a distance.[3]

The inclusion of these diverse things in a single category is inexplainable to those outside of the culture but perfectly natural to those within it, so natural that members of the culture feel no need to explain why "suckling pigs" and "those that resemble flies from a distance" should be in the same category.

The same quirkiness is true of the museum's organization, and to an outsider it could appear just as absurd. According to its website, the Metropolitan Museum of Art in New York organizes itself in the following way:

First Floor	Second Floor
The American Wing	The American Wing
Arms and Armor	Ancient Near Eastern Art
Arts of Africa, Oceania, and the Americas	Asian Art
Egyptian Art	Drawings, Prints, and Photographs
European Sculpture and Decorative Arts	European Paintings
Greek and Roman Art	European Sculpture and Decorative Arts
Robert Lehman Collection	Greek and Roman Art
Medieval Art	Islamic Art
Twentieth-Century Art	Musical Instruments
Special Exhibition Galleries	Twentieth-Century Art
Great Hall	Shops
Thomas J. Watson Library	
The Grace Rainey Rogers Auditorium	
Museum Restaurant	
Shops	

[3]Jorge Luis Borges, "The Analytical Language of John Wilkins," in *Other Inquisitions* (New York: Simon and Schuster, 1965), 103.

Although this list is instantly recognizable as the organization of a major museum, its organization is irrational, idiosyncratic, and lumpy. Under one category—all of the Met's works on display—Arms and Armor belongs in the same overarching group of things as Prints and Photographs. The American Wing contains something different from Arts of Africa, Oceania, and the Americas, despite the fact that America is, presumably, part of the Americas. European Sculpture and Decorative Arts are things different from Greek and Roman Art, even though both Greek and Roman art are European. Medieval Art is a single, homogenous thing, with no apparent place of physical origin. Three parts of the museum are named after presumably wealthy patrons, who are memorialized by their bequests. And although there is a space devoted to Ancient Near Eastern Art, there is no mention of recent Near Eastern art. (These organizational quirks are not necessarily the result of a museum's inability to organize. A museum is limited in its ability to display a consistent record of all forms of art if it has gaping holes in its collection. For example, it can't describe twentieth-century art without any **surrealist** work—work from a twentieth-century art movement that explored the irrational and the unconscious. At the same time, museums can have surprising specialties, the result of bequests from donors with highly specialized collections. The St. Louis Museum of Art does not have a reputation the size of the Met, but it does have America's finest collection of **German Expressionism**—a post–World War I movement that heightened emotional and personal interpretation of its subject matter.)

What other factors have gone into the organization of this material? As we will discuss in the next chapter, the organization is partly explained by a history of Western European and American colonization. During the nineteenth century and beginning of the twentieth century, it was possible to go to the Near East, for example, and take away what was most interesting to Westerners—that which influenced Western Europe and which was archeologically significant. (Not surprisingly, the looted countries are now demanding the return of many of these treasures, the sculpture from the Parthenon in Athens—known as the Elgin marbles, after the British Lord Elgin, who "collected" them—being the most famous example.)

Nationalism, then, also comes into play in the museum's organization. However, it shows up not just in the relics of colonialism but also in the subtle ways the museum celebrates national identity. The organization of the Metropolitan Museum suggests that, for its typical audience, the United States *deserves* attention separate from other countries of the Americas. Lumping all of these objects together would imply that works of the United States were less important to the museum's goals.

As we have already pointed out, wealthy benefactors, too, have played a part in the museum's organization. Almost all museums have been given large financial bequests or entire collections by benefactors who were subsequently rewarded with the dedication of a building or gallery in their names. Sometimes their collections were donated with the stipulation that they remain intact (the Met's Robert Lehman Collection is a good example of this). And so, within one of its galleries a museum may demonstrate startling organizational idiosyncrasies, re-creating a donor's living room, complete with a jade collection, porcelain,

and Renaissance painting. To include such collections along with Arms and Armor, Restaurants, and Shops is neither more nor less absurd than to put together "suckling pigs" and "those that resemble flies from a distance." As Borges notes, "there is no classification of the universe that is not arbitrary and conjectural."[4]

Some categories within the museum are much more specific than others. This specificity also says something important about the museum's organization. In the big comprehensive museums, art of other cultures is called so by name and is frequently lumped together as "non-Western art." Western art, on the other hand, is unidentified at this general level (there apparently is no such category) and is instead specified by nationalities and periods. Western art, apparently, merits greater differentiation than art of other cultures—perhaps because museums have more of it, know more about it, and think it is better and more important.

Although it *is* arbitrary to place armor and photography on a similar plane, within many of these categories there is a consistent organizing principle that promotes certain values. Chronology—not gender, race, theme, subject matter, or social function—dominates the museum structure. But it's a funny kind of chronology. Museums give a sense of historical continuity with moments of rupture. Such moments of rupture between periods are almost always defined as a reaction against what has preceded them. For example, consider the break from the French academy by **impressionism**. The academy was the official "union" of French artists. Only members of the academy had access to official government exhibitions. Like all large-scale organizations, it was conservative, slow to change. In the history of art, nineteenth-century academic painting (with its interest in slick, naturalistic representations of mythological and historical subjects) is suddenly broken off by the revolution of impressionism (a kind of painting that emphasized the moment, light, and personal interpretation). After a decisive breaking point, say the "Salon des Refusés" of 1863 (a famous Paris exhibition in which artists rejected by the academy's selection committee set up their own counterexhibition), the museum, by its chronological ordering, tells us that art history took a dramatic turn.

The museum's chronological categorization reveals what for many is an implicit belief in progress. Raphael's art "developed" from Giotto's art. Manet's flattened representations "evolved" into Cézanne's more geometric abstraction, which "gave birth to" Picasso's and Braque's fracturing of the pictorial space that became known as **cubism**. The stories are told as the stories of the new: What Manet, Cézanne, and Picasso and Braque did was new, original. The first artists to do new work are always presented as the most important. Consequently, it's no surprise that this story of art is the story of heroic individuals, whose names are carved into the friezes that run around the building (Figure 1.5). (Within this chronological and progressive ordering museums situate their celebrity pieces, that is, pieces that are famous for being famous, not necessarily for being "good."

[4]Borges, "Analytical Language," 104.

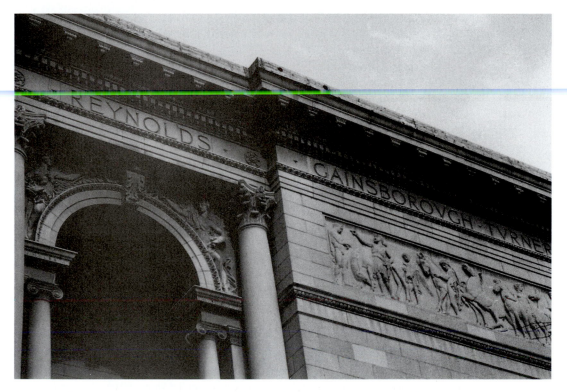

Figure 1.5 Frieze with artists' names, The Art Institute of Chicago. (Photo courtesy of the author.)

For example, the Louvre has signs that direct tourists to the *Mona Lisa* and the *Venus de Milo*; the Rijksmuseum has its *Night Watch*; and the Art Institute of Chicago has *American Gothic*.)

In these chronologically based versions of art history, although people are directed to notice the triumphant pieces of an historical period, they are not invited to think about what is left out of the chronology, and they are given a narrative with as much consistency within it as possible. A museum, by its arrangement, tells what it thinks is the story of art. To admit to inconsistencies or gaps is to admit that the collection is incomplete.

This consistent story is typically one about originality: those who *first* do something are given pride of place. The emphasis on originality results in the inclusion of some kinds of work and the exclusion of others. There is a de-emphasis on collaborative work and a devaluing of whole categories of post-Renaissance art that tend to be anonymous (for example, textiles, folk art, ceramics). Ideas of originality and progress devalue work that isn't breaking new ground, that is formally conservative. The late-nineteenth-century French academic painters were technically adept painters, but according to the museum, they were not moving painting along. So, for much of the twentieth century, they have been a footnote to the museum's main story.

To attempt to write academic painters back into art history would be to radically change the form of art's story, and in 1987 the Musée d'Orsay did just that. The Orsay, a converted Paris railroad station, was created as a museum of late-nineteenth-century art. It was conceived of as a radically different art museum, a museum of the social history of art from 1848 to 1914, dates that were significant for political reasons (a revolution and a world war), not aesthetic ones (such as would be the case with 1863, the year of the "Salon des Refusés"). The Orsay's organizers and designers attempted to bring together all the kinds of art being done during the late nineteenth century to create a whole context of art of the time. In doing so, the Orsay veered away from a construct of progress, in which one thing followed another, toward an idea of simultaneity. In particular, it elevated the previously dismissed late-academic work just by the act of displaying it. And when museums deviate from the standard, seamless story, people get upset. Critic Alain Kirili, in a response entitled "Self-Hatred and Castration at Orsay," fumed that the museum's "lack of consideration for what should be a clear-cut hierarchy strikes me as both frightening and threatening." In fact, Kirili characterized the museum's lack of hierarchy as "a project of incredible violence."[5]

Further, neat chronological ordering does not always work, and at times museums implicitly acknowledge that. Occasionally one finds anomalous categories within a historical or national progression, such as a gallery of Dutch still life painting—a very specific organization by nationality and genre found within a museum that may otherwise be organized totally by nationality and chronol-

[5]Alain Kirili, "Self-Hatred and Castration at Orsay," *Art in America* 76 (January 1988): 95.

ogy. But this exception is still within an overall chronological setting: this gallery would not mix twentieth-century still lifes with seventeenth-century work. The still lifes of Piet Mondrian and Pieter Claesz would be in separate rooms.

Museums also typically separate the "major" arts, such as painting and sculpture, from the "minor" arts. As such, textiles, ceramics, furniture, and metalwork are rarely shown with the painting and sculpture of the same period and place. And with the disappearance of the "minor" arts, the larger context for these paintings and sculpture disappears.

As we will discuss later, these categorization decisions about genre, chronology, and nationality are conservative: once in place, these categories are not easy to change. The Italian Renaissance is here to stay.

Additional Values Promoted by Museums

Museums promote further values that are not specifically tied to their organization. To begin, the museum is an institution that sees itself in the role of educator. The Getty Museum in Los Angeles, for example, surrounded by olive groves and situated on a hill high above Los Angeles, can be reached only by a shuttle train. One could hardly imagine a more secluded spot for the contemplation of art (Figure 1.6). But it boasts a significant educational outreach program, which it provides free of charge. As its website claims, "The Getty Museum works with school groups from the primary grades through college, hosting up to 90,000 students a year. All of our lessons are taught by professional Museum educators and provide an opportunity to study a limited number of objects in depth."[6] In addition, the Getty offers staff development workshops, collaboration workshops, and a teacher resource center. The Getty is typical; one would be hard pressed to find a single museum for which education is not a central activity.

What kinds of values are implicit in a museum's education programs? First, this is not the kind of education that gets one a better job. Instead, the values are broader and more diffuse: education programs suggest that the museum's objects are worth being educated about, that art makes people's lives better, that art provides an entry into high culture. These works reveal important things about the culture of their origin.

In addition to educational programs, the contents of museums themselves contain and promote values. Some critics have suggested that museums are racist and gender-biased. They point to the fact that museums are more inclusive of white males than of other people, as is evidenced by the identity of their donors, their boards of trustees, the creators of their artworks, and the issues these artworks address. Artists themselves are becoming increasingly aware of these issues. The activist art group Guerrilla Girls posed this question in their 1989 poster: "Do women have to be naked to get into the Met. Museum?" The poster

[6]The Getty, 5 January 1999 <http://www.getty.edu/visiting/educ-programs.html>.

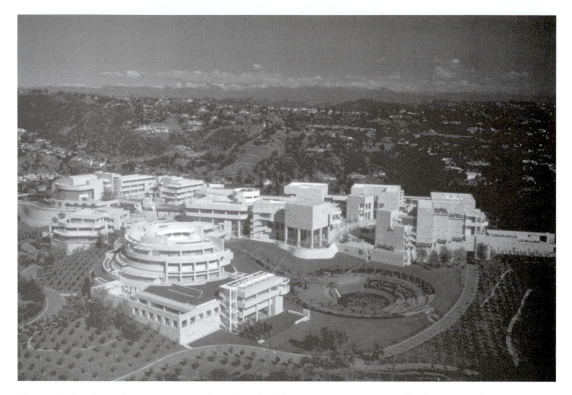

Figure 1.6 Getty Museum, Los Angeles, California. (© Gunnar Kullenberg/Stock Connection/ Picturequest)

went on to say that "less than 5% of the artists in the Modern Art Sections are women, but 85% of the nudes are female."

But it is also true that museum directors are aware of and responsive to such issues. When the Philadelphia Museum of Art asserts that central to its mission is to reach "an increasing and increasingly diverse audience as a source of delight, illumination, and lifelong learning," there is little reason to suspect its sincerity. Over the past few decades, museums have expanded the range of their collections to include genres and media that historically have involved a large number of female and minority artists. Moreover, many museums have made a concerted effort to show the work of traditionally excluded groups and to stress the social context in which art has been produced. Yet it must be admitted that the collections of and regular visitors to major museums are changing very slowly. Why might this be so? In the first place, it is very hard for a museum to change the emphasis of its collection, even with an aggressively progressive collections policy. The collections, after all, are historical and highly dependent on what benefactors donate.

Museums promote other values as well, values that are perhaps even harder to change (if, indeed, a given museum would want to change them). For a number of reasons the museum is more a part of capitalist society than a critic of it. Its entanglement with the economic system is shown by its emphasis on defining artworks as valuable objects that are acquired through the philanthropy of wealthy donors (who are acknowledged on the labels). As part of capitalist society, museums appeal to a class elitism by hosting exclusive parties and publicizing major donors. Not surprisingly, the museum is partly a story of ownership, and this story is extremely interesting to the press. A recent article in *ARTnews* reports on an important bequest to the Metropolitan Museum and the Museum of Modern Art (MoMA). The article *begins* by stipulating the monetary value of the bequest and makes it clear that the value was equally important to the museums: "The Metropolitan Museum of Art and the Museum of Modern Art have announced bequests from department-store heiress Florence May Schoenborn totaling over $150 million." Only then does the article go on to identify the actual artists included in the bequest.[7]

Museums also promote *formal* values; that is, they define artworks by what they look like—how they are put together rather than what they were put together for. They accomplish this by decontextualizing artworks. For example, religious objects are displayed outside of their ritual context and political works outside of their social context. Their original functions do not come to the foreground. Although we want to know more about them and sometimes stoop over to read the label that gives us this information, the primary reason these works are in the museum is for their inventive and expressive use of composition, pattern, texture, and color—not for such things as their politics, religious orthodoxy, or historical accuracy.

[7]"One Donor, Two Museums," *ARTnews* 96, no. 1 (January 1997): 37–38.

This leveling tends to obscure the various functions these works may have had in their original contexts. There are so many diverse forms of art within a museum that the only thing that can join them into a single category is their formal values. By placing a Descent from the Cross (taken from a Renaissance chapel) next to a depiction of Venus and Cupid (taken from an Italian nobleman's bedroom) next to a de' Medici portrait (taken from a ducal palace), viewers are not encouraged to use the Descent as an object of Christian worship, to view the Venus and Cupid as a sexual stimulant, or to think about the configurations of political power suggested by the portrait. By implicitly prizing domestic, religious, and political artworks for their formal values, museums downplay the power of sexual, religious, and political belief. Even such a rare exception as New York's The Cloisters, where medieval work is contextualized, placed in a monastic setting that was shipped over from Europe, the cloister itself has become decontextualized from its original function. The Cloisters is a transplanted museum object; anything in it has been selected for its high art value. Viewers do not use the museum for worship.

In the museum, viewers are encouraged to look at works formally but to overlook the ways in which in their original context these artworks would have been used. As the art historian André Malraux asserts, in the museum everything becomes a *picture*; museums "divest works of art of their functions."[8] Everything is of interest, but nothing is of consequence. The activity that the museum esteems is called aesthetic contemplation, a type of experience in which the visual pleasure of the object is enjoyed in a context that is free from the distractions of the world. The museum's seclusion from the city, its white walls, the restrained whispers of the viewers, the lack of background music, even the frames of the artworks themselves are all designed to separate the work of art from the "real" world and to draw attention to the work's formal properties, to what it *looks* like.

Museums communicate values, some implied, some overt: that education about art improves society, that the artworks in the museum are the most worthwhile, that art has economic value, and that artwork's formal values are most important. Further, museums implicitly tell their patrons how to behave; they give instructions on how to use the art that they contain. And they wish to succeed in this. For museums to reach their goals of inclusivity and education, a wide range of visitors need to be convinced that the values represented are values they will find useful in their lives. Museums are the legitimating history of *all* cultural expression and attitudes to those expressions. As we will see later in this chapter, museums do not just show art, they define art; the sorts of things that are in museums are what we say is art, or, more specifically, **high art.**

The History of Art Museums

The word *museum* has not always meant what it means today: a collection of specimens assembled for study and enjoyment. The origins of the modern West-

[8]André Malraux, "Museum Without Walls," in *Voices of Silence* (Garden City, NY: Doubleday, 1953), 13–14.

ern art museum date back to ancient Greece. In Greece the term *museion* meant a sacred place, the Muses' realm, where under the inspiration of the Muses (nine goddesses, daughters of Zeus, who guided the arts and sciences) ceremonies and literary competitions took place. Philosophers such as Plato, Pythagoras, and Aristotle merged the idea of a sacred place and a place of teaching.[9] Aristotle's school, for example, began to collect and classify specimens; this part of his facility became known as a *museion*. The great Museum of Alexandria, Egypt (290–48 B.C.), was the earliest known use of the term as we recognize it today. The Museum of Alexandria created a comprehensive, encyclopedic collection of specimens and artifacts for classification, preservation, and research.

With the burning of the Museum of Alexandria, museums disappeared for a while from Western culture. The museum reemerged during the Renaissance with a revival of interest in ancient learning. Using objects brought back from the great voyages of exploration, the aristocracy and wealthy classes collected items in **Wunderkammern,** "cabinets of curiosity." Such collections combined animal and plant materials, shells, fossils, human artifacts, and minerals, along with books, paintings, and drawings. The intent was both to stimulate learning and to dazzle and amuse. A young visitor to the collection of Sir Ashton Lever wrote the following undistinguished but telling lines:

> View there an urn which Roman ashes bore,
> And habits once that foreign nations wore,
> Birds and wild beasts from Afric's burning sand,
> And curious fossils rang'd in order stand.[10]

Most of these "cabinets" were in fact palace rooms, where privileged people could see the precious objects. For example, the collections of the de' Medici family in Florence, Italy, were housed in a special building, the Galleria degli Uffizi, in 1570.

The next major shift in the museum was to a more egalitarian, pedagogical place. In the seventeenth century, some aristocratic and church collections were opened to the "public." This egalitarianism was not particularly far-ranging, though; the "public" was understood to include only students, the upper classes, and artists.

During the late eighteenth century, emphasis on education and a new idea of what constituted the fine arts brought about a separation of paintings and sculpture from other kinds of objects. It also resulted in the founding of museums that exist yet today. Following the French Revolution, in 1792, the Louvre and its contents (the palace and collection of the deposed king) were declared national property and opened to the public in 1793. The Louvre was "the most politically significant and influential" transformation of a royal collection to a public art museum.[11]

[9]Alma S. Wittlin, *The Museum: Its History and Its Tasks in Education* (London: Routledge & Kegan Paul, 1949), 1.

[10]Quoted in Wittlin, *The Museum,* 66.

[11]Carol Duncan, *Civilizing Rituals: Inside Public Art Museums* (London: Routledge, 1995), 22.

Like many museums today, it did not open without controversy. There was a debate about whether in its organization the Louvre was truly a public institution. There were those who favored an "eclectic," aesthetic organization that focused on composition, subject matter, and use of color. This method of organization was based on a very specific idea of taste more than on rational, highly systematic principles. Calling this approach elitist, others favored a more historically and stylistically systematic approach, one that was more accessible to the general public and more in line with the ideals of the French Revolution. When the collection was rehung in 1801, according to the latter organizational approach, supporters pointed out how the chronological arrangement highlighted the stylistic and historical development of art and downplayed their original functions as promoters of an antirevolutionary sensibility. In the new Louvre, portraits of kings and religious images no longer had the ideological function they once had.[12]

The history of the Louvre clearly shows that, early on, museums were seen as tools of national identity. The National Gallery in London, the Hermitage in St. Petersburg, and the Smithsonian in Washington have all attempted, in different ways, to symbolize and glorify a nation and reinforce the nation's social order. As mentioned earlier, one of the primary ways in which nations were glorified was through the acquisition of treasures from around the world. For example, Napoléon Bonaparte, on the conclusion of his Italian campaign in 1797, returned with what can only be called the plunder of Italian art. One of the carts carrying this treasure was loaded with the ancient marble sculptures *Apollo Belvedere* and *Clio*. On the cart was an inscription that proclaimed: "Both will reiterate our battles, our victories." Another banner read: "Artists hurry! Your masters have arrived." A celebratory song composed for the arrival of Italian art had the following chorus:

> Rome is no more in Rome;
> Every Hero, every Great Man
> Has changed country:
> Rome is no more in Rome,
> It is all in Paris.[13]

There was a boom in museums during the late nineteenth century, especially in the United States, as a result of an expensive acquisitions program. These American museums, often civic museums, such as The Art Institute of Chicago, were founded out of a very different experience than European revolutions and nationhood. Although nationalism was again a high value in the founding of these museums, there were also other things at work. Wealthy benefactors and trustees wanted to make the United States a more civilized place, to domesticate the immigrant, and to educate and spiritually enlighten the lower classes.

[12]Andrew McClellan, *Inventing the Louvre: Art, Politics, and the Origins of the Modern Museum in Eighteenth-Century Paris* (Berkeley: University of California Press, 1999), 107, 113.
[13]Quoted in McClellan, *Inventing the Louvre,* 123.

The democratic and educational functions were limited, though, for directors and benefactors also wanted to protect the works as a symbol of their prestige. Not surprisingly, many museums began as memorials and shrines to wealthy benefactors, and their names indicate this: the Frick, the Getty, the Carnegie, the Whitney, the Guggenheim, and so on. The naming of museums and the galleries within them indicate a shift away from democratic values. According to the art historian Carol Duncan, with the emphasis on benefactors "the museum now casts you as a visitor come to admire the possessions of a particular family or individual important enough to claim a semi-private precinct in the midst of a public, presumably educational space."[14]

Today's art museums thus have an enormously complicated history. In recent times, different types of art museums and places to display art have proliferated. There are comprehensive museums, such as the Met; there are specialized museums that deal with one kind of art, such as the Orsay in Paris and the Museum of African Art in New York; there are noncollecting art centers, such as PS1 in New York (until it joined with the MoMA); there are commercial galleries, such as Leo Castelli in New York, which brought **pop art** to the American public; and there are cooperative galleries and alternative spaces, sometimes operated and run by artists themselves.

Perhaps most notably, though, museums today, uncertain about their role in contemporary culture, face a kind of identity crisis, feeling alienated from the impulses upon which they were founded. It's not just that a lot of collecting resulted from colonial impulses; there are even more basic questions: What does it mean to collect? That is, who decides what is worth collecting, and what kinds of things are collected? After all, there are a lot of things that are central to contemporary art that are not collectible, such as **installation** works, **performance art, site-specific work,** and video art (which is not dependent upon being housed in a particular place). There is also a crisis about value decisions. Who is the museum for, and how can it attract a broad range of people if the collection does not reflect their identities? What is the place of a museum in the technological age? Is the museum obsolete?

The Canon

Museums' values and the similarity of their look and feel come together most dramatically in their collections. Museums tend to contain work by the same people. For example, every comprehensive North American museum either has or aspires to own a Warhol soup can, a Picasso collage, and a Monet haystack. They also give pride of place to the same people. A museum's Rembrandt, for example, is never tucked away next to the elevators or stored in the vaults. The gift shop will stock postcards of Rembrandt's work, but one could not count on finding postcards of the work of his lesser-known contemporary Willem Kalf.

[14]Duncan, *Civilizing Rituals*, 61.

Evidence of Rembrandt's importance is not found just in the museum. Rembrandt is also important in art-history textbooks and in university curricula, and his work fetches huge prices at art auctions—if it is even available.

This pride of place is obviously not limited to Rembrandt. It extends to a whole group of artists and their work and gives a recognizable shape to art history. Look at the big three basic art history textbooks by Janson, Hartt, and Gardner. There is an enormous amount of overlap among them: they all include Michelangelo's *Sistine Chapel* and his *David,* at least one Rembrandt *self-portrait* (see, for example, Color Plate 14), David's *The Death of Marat,* Goya's *The Third of May, 1808,* Picasso's *Les Demoiselles d'Avignon* (see Color Plate 6), and something by Pollock. There is as much similarity to the selection of artworks among the big three anthologies as there is to the opening news stories broadcast by the major national networks.

Nothing of what we assert here is surprising; many people recognize that there is a recurring group of works and artists in textbooks and museum collections. Art historians and critics call this body of work the **canon.** The term *canon* was originally used theologically, to describe that group of sacred writings included in what we now call the Bible. The question of which books to include in the Bible was at some times considered settled and at other times the subject of intense debate. Those sacred writings that were eventually included among the books of the Bible were considered authoritative, holy, inspired by God. The term *canon* was later secularized and used to describe the central works in such fields as literature, music, and art history. But its basic meaning of inclusion (and a necessarily corresponding exclusion) is maintained. In art, the canon can be described in two similar ways: on the one hand, it is that *generally* agreed upon body of artworks that people find central to understanding and appreciating art; on the other hand (and this is particularly true for museums), the canon also refers to those generally agreed upon artists whom people find central to understanding and appreciating art. Picasso is part of the canon, but so is his *Les Demoiselles d'Avignon.*

The recurrence of artists and works in museums and textbooks suggests that there is agreement about the canon. But consider the type of agreement. Although some may argue about whether even the idea of a canon is a bad thing, most would acknowledge that some version of it will always exist. Debate swirls, though, over the canonicity of specific individuals and movements. Such debate can be very specific: Is this particular portrait by Rembrandt or by a lesser artist? Was Renoir a major figure in early modern art, or was he merely an ingratiating hack? Is there any important early-twentieth-century British art at all?

Further, the principles by which the canon is formed are not clearly articulated, understood, or agreed upon. For example, the criteria by which someone or something is considered important enough to enter the canon keep shifting: often a salient criterion in one era might not function in the same way for work of another era. Consider the history of beauty over the last two centuries. The portrait paintings of Thomas Gainsborough may have entered the canon because at the time they were considered beautiful. But we no longer understand beauty in the same way. Beauty in the eighteenth century was seen in works that had

balance, grace, and pleasant harmony. Beauty had very clear consequences for form and subject matter. Gainsborough's painting *Robert Andrews and His Wife,* for example, is perfectly split between a foreground composed of a genteel couple, relaxed and gazing toward the viewer, in balance with their possessions, particularly the pastoral grounds of their estate, which occupy the deep space on the right half of the painting (Color Plate 1).

The nineteenth-century **romantics,** with their insistence upon the importance and uniqueness of the creating genius, started to shift beauty away from the strictly pleasant and in the direction of what they called the **sublime.** Art had to be something more than just pleasant; it had to show some kind of struggle, perhaps even some unarticulable terror. Although many accepted the new romantic articulation of beauty, such acceptance did not always lead to the exclusion of the previous articulation. "Beauty" sometimes implied one or the other, and sometimes it implied both. A layer of meaning was just added to the term, and in the next century, yet another layer.

At the beginning of the twentieth century, the modernists, less interested than the romantics in what lay beyond their consciousness, defined beauty as the accurate expression of what lay in their minds, an expression that could include their neuroses, inconsistencies, and fantasies. Because of its earlier associations, from which modernists wanted to remove themselves, the term *beauty* was used less and less and was replaced by the term *expressiveness.*

What this all suggests is that if there are agreed-upon aesthetic standards, such as beauty, over time they become so vague as not to be clearly applicable. But perhaps because of this vagueness, these principles still have a lot of power. Beauty is still part of aesthetic discussion. Thus, although Gainsborough's work was considered beautiful in the classical sense, contemporary viewers need to adjust their definition of beauty. We would never enter someone in the canon now who painted like Gainsborough. (In fact, in an important way, although it is *possible* to paint like Gainsborough in the twentieth century, such painting could not communicate in the same way as Gainsborough's work did in the eighteenth century.)

But it's not just principles that change and make the values of the canon unstable, it's also context. (Of course, the two cannot be completely separated.) For example, artists from the past, whose work then seemed invisible, now seem to offer solutions to questions that only recently have been recognized. The Mexican painter Frida Kahlo, whose powerful autobiographical images entered the canon during the 1980s, was relatively obscure up to the time of her death in 1954. But with the new interest in the work of women and previously excluded ethnic groups, Kahlo offers insight into the way paintings might use a highly personal vocabulary to address gender, ethnicity, and illness (Color Plate 2). When these issues took on a central role in the culture, her work became important.

Conversely, there are also artists who later are seen to be *less* central to the canon because, looking back, historians perceive that the art world went off in a completely different direction. For example, in the 1930s and early 1940s, the **social-realist** painter Ben Shahn's canonical status seemed assured; his figurative, narrative work, with its strong political message, embodied the central features

of social-realist painting. But his work from the later 1940s and the 1950s was eclipsed by abstract expressionist painting, such as that of Jackson Pollock. **Abstract expressionism,** in contrast to social realism, emphasized the personal and emotional in works that were perceived as spontaneous, abstract applications of paint, stressing process over product, and the personal over the social. Shahn's 1945 *Liberation,* with the pathos of its children playing amid the ruins of war, did not seem as central to the story of the chronological development of art as did Pollock's 1950 *Autumn Rhythm* (Figure 1.7 and Color Plate 3). To artists in the 1950s, Shahn's interest in social realism seemed an incomprehensible avoidance of the *real* issues of art, which were the abstraction and heroic self-expression of Pollock.

Looking back at the past, art historians understand the artwork in the context of its own time first of all, although historians don't always use the dominant aesthetic standards of that time. They don't evaluate Manet, for instance, by uncritically using the dominant aesthetic standards of his time. If they were to do so, they would sound like the critic Amédée Cantaloube, who in 1864 called Manet's work "impulsive, barbarously drawn . . . some fused traces of the temperament of a colorist."[15] But historians do evaluate him *in relation* to those older standards—one reason Manet looks so good is that he shows the limitations of the aesthetic standards current at his time. Particularly in the twentieth century, an artist's canonical status was frequently decided according to how well he or she exemplified newness, originality, progress. (These are all ways of talking about how *influential* an artist is.)

Even though aesthetic standards and context shift over time, things that are no longer "good" in the sense that they once were, can yet remain in the canon. They remain in the canon because "importance" is a more central feature of canonical works than is "goodness." In the case of the impressionist Auguste Renoir, what once was good about his work (and thus important) is now merely important. Early in the twentieth century, Renoir was seen as one of the great forerunners of modernism, as one of the heroic leaders of a revolution in painting, because of his radical shift in the approach to surface and light. But Renoir's big retrospective during the mid-1980s, unlike an earlier major show for Monet, killed his reputation among his elite and professional audience. For some, his downfall was pleasant. Critic Walter Robinson, clearly enjoying himself, writes, "Poor Renoir. There he was, leading painter of the good life in 'modern' Paris, a veritable Pollyanna with a paintbrush, recording classic scenes of idle delight with unrelenting good cheer and a shimmering dapple of rainbow-bright hues. And then look at what happens. His subjects all turn to 'kitsch.'"[16] Such damnation makes Renoir's current support nervous and muted in comparison to earlier claims for his greatness and aesthetic excellence.

[15]Quoted in Michael Fried, *Manet's Modernism: Or, The Face of Painting in the 1860s.* (Chicago and London: University of Chicago Press, 1996), 304.
[16]Walter Robinson, in "Renoir: A Symposium," *Art in America* 74 (March 1986): 120.

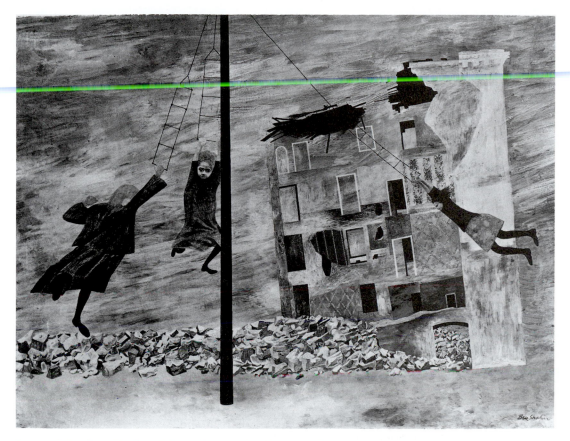

Figure 1.7 Ben Shahn, *Liberation,* 1945. Tempera, 29¾ in. × 40 in. Museum of Modern Art, New York. James Thrall Soby Bequest. (Photograph © 2000 The Museum of Modern Art, New York. © Estate of Ben Shahn/Licensed by VAGA, New York, NY.)

What are the reasons for such drastic change in evaluation, even positive evaluation? Some of the rereadings are based on formal principles: Peter Schjeldahl complains that Renoir's colors are "tonally chaotic," and Michael Fried condemns his lack of touch. But these are not just formally based criticisms, for they are usually tied to the idea that Renoir wasn't really an innovator. As Carter Ratcliff writes, Renoir was "not a radical artist, but [he is] important because he shows how easy it is to look like one, to be scorned and then revered as an 'intransigent,' while preserving the authority of standard forms and taste."[17] By the end of the twentieth century, Renoir was in the canon because he was *important,* because people once thought he was great and innovative. Impressionism still cannot be taught without teaching Renoir.

Thus, aesthetic excellence is often a criterion for admission to the canon, but it is not the defining feature of the canon. All works in the canon are thought to be important (that is, influential), but the canon doesn't consist of all the best paintings ever done. Picasso's *Les Demoiselles d'Avignon,* clearly in the canon, is one of the most important paintings of the twentieth century, but it can be argued whether it is one of Picasso's best.

Yet although importance is the ultimate criterion for the canon, importance is not a stable category either. There are different kinds of art historians who have different ideas of the story of art, of what is important, of what constitutes an *event* in art history. The marxist historian, the psychoanalytic historian, the feminist art historian—all are constructing different art histories and are choosing different things to be important. They are working with different narratives, and each is constructing a different story of art.

For these and many other kinds of art historians, although they often come up with quite different choices, importance typically refers to originality—an important work is a work that did something *first.* For example, any artist who continued in the style of Jackson Pollock after his accomplishments is considered a lesser artist and, consequently, risks being left out of the *story* that is the canon.

Although some of its principles are unstable, the canon itself is quite stable—to some, infuriatingly so. Despite all the strenuous wrangling (and people risk something as important as academic careers on this), the canon is hard to change. Certainly, artists become more or less canonical—think of Renoir. But it is easier to add people to the canon than to remove them. Once artists are firmly established on the walls of a museum, they don't leave the building. Aesthetic standards can shift, but because of the emphasis on importance, other shifting values of the canon rarely knock something out of the canon.

Who decides a work is important? There are several converging factors: the museum, academia (art history departments), art critics, artists, and audiences. To begin, the museum has a peculiar role in shaping the canon. On the one hand, it provides the objects and decides where to display them. Public access to the museum allows anyone who wishes to look at its collection and makes it possible

[17]Peter Schjeldahl, Michael Fried, Carter Ratcliff, in "Renoir: A Symposium," *Art in America* 74 (March 1986): 107, 108, 111.

for works to be known around the world and to a degree that would not be possible if they were housed in private collections. In fact, if there were no public museums, the very idea of a canonical object would be threatened. It's hard to imagine a canon composed of objects that no one had access to. The canon consists of those things and only those things that are accessible—and the museum is essential, for it decides what to collect and what to show. The major art history textbooks back this up: almost all of the pre-twentieth-century art they show (and certainly all of the major works) are housed in institutions open to the public.

Art history departments also help shape the canon. Because they could not possibly show every slide of every work of art, they have to make decisions about what is important. Especially in art survey courses that cover anywhere from 400 to more than 1,000 years of art history in one semester, instructors have to decide which works to show. Art history departments also have to decide which courses to offer. Should one teach Italian Renaissance art every year, or should it be alternated with a course on African art? Further, art historians train many studio artists and most of the art critics and museum curators. Art historians write the textbooks and the articles that make explicit arguments for the centrality to art history of one artist and the marginality of another. They implicitly decide which artists are just not interesting enough to write about.

Art critics, who write for the press about contemporary art, also help shape the canon. They and their editors decide which exhibitions to review. Over a number of years they can significantly affect the development of the career of a single artist or group of artists—or they can attempt to condemn new work to obscurity, either by trashing it or by ignoring it completely. Clement Greenberg, the most influential American critic of the twentieth century, did much to develop the career of the sculptor David Smith. Not only that, he tried to change it. After Smith died, Greenberg, irritated with Smith's late decision to paint his sculptures, stripped some of their primer and let other fully painted ones gradually flake and rust in a field. Although this reworking fit Greenberg's theories of progress in the development of sculpture—and it did not eliminate Smith from the canon—it attempted to change what Smith's work meant.

Artists have yet another role in shaping the canon. Obviously, they produce the work that may become canonical. But, as mentioned, one of the marks of the canonical work is that it was or is influential. Marcel Duchamp's *Fountain,* a mass-produced urinal—which Duchamp attempted to exhibit under the pseudonym R. Mutt—changed the whole status of the art object. Duchamp made possible artworks based on the premise that choosing something can replace making something. In Duchamp's words: "Whether Mr. Mutt with his own hands made the fountain or not has no importance. He CHOSE it. He took an ordinary article of life, placed it so that its useful significance disappeared under the new title and point of view—created a new thought for that object."[18] Artists also shape the canon in that later artists validate earlier artists, as is seen in the

[18]Quoted in Kristine Stiles and Peter Selz, eds., *Theories and Documents of Contemporary Art* (Berkeley and Los Angeles: University of California, 1996), 817.

1980s text and image works of Barbara Kruger, who revived an interest in the 1930s political, photographic collages of John Heartfield and Hannah Hoech.

Collectors and art dealers, with their participation in the art market, also shape the canon. Through their spending habits, collectors validate current and older work. Further, when collectors die, they donate their work to museums, especially if a museum has treated them with respect and deference while they were living. These collections are the backbone of many museums' holdings: the Walter J. Arensburg collection at the Philadelphia Museum of Art, the Hearst collection at the Los Angeles County Museum of Art, and the Lilly P. Bliss collection at the Museum of Modern Art in New York. Not surprisingly, boards of museums typically consist of collectors, not art historians or artists. Dealers also shape the canon through their influence on the art market. They aggressively promote individual artists and whole movements, such as Daniel-Henry Kahnweiler for cubism and Leo Castelli for 1960s pop art. Dealers also manipulate and benefit from scarcity; they want to make the objects rare and demand high. When things are scarce and there is a lot of demand for them, they are seen to be important.

To a lesser degree, the general audiences who file through museum doors on Sunday afternoons also shape the canon. They buy books, and they show up in the hundreds of thousands for blockbuster shows. But the canon was not formed on the democratic principle of majority rule. If it was, the highly popular Andrew Wyeth might well be the giant of twentieth-century art instead of a minor figure in the canon.

Exclusion from the Canon

As discussed earlier in this chapter, the work collected in museums is not demographically representative. This is not surprising. Given all the complex forces that go into shaping the large comprehensive museums, it is not just a matter of quality that guarantees inclusion in or exclusion from the collection. But just what are the forces that have kept individual artworks and artists, as well as entire groups of people and genres of art, excluded from the canon? Are there coherent principles operating here, or is it just haphazard?

The two most pervasive attitudes that have resulted in excluding groups of people and works from the canon are racism and sexism. Racist and sexist attitudes have permeated Western society, and so it would be reasonable that they would touch the museum as well. Racism and sexism did not drop away when decisions were made about purchases for, the organization of, and special exhibitions in the museum. Being African American or female made it highly unlikely that those canonizing forces would recognize such an artist. The fact that many museums are an expression of nationalism has merely intensified these issues.

That these attitudes were also a part of the society at large meant that racism and sexism began to shape the canon well before an individual museum may have engaged in a particular racist or sexist act. Critic Linda Nochlin has argued in her groundbreaking feminist essay "Why Have There Been No Great

Women Artists?" that there were large social forces that made it incredibly diffi-cult for women to be artists. For example, in the nineteenth century, women art students were not allowed to work from nude models, even female nudes. Since the important art of the time was based on the human figure, women artists were nudged to do work that was less mainstream: still lifes and landscapes. For many years, women artists were also not allowed to be members of the academy. (Women were eventually admitted to the French academy, but only after the academy had lost its prestige to the impressionists.) Further, Nochlin argues, few women were encouraged to be artists by their families and peers. What this resulted in, Nochlin maintains, was a lack of women who actually tried to be artists. All of these things worked together to make it seem *natural* to those in power that women were not great artists; consequently it was not disturbing to museums at, say, the turn of the last century that women artists were not repre-sented in their displayed works.[19] Similar kinds of forces operated to exclude ethnic minorities.

Museums and the canon also excluded certain types of objects. They ex-cluded, for example, works that weren't primarily used for aesthetic contempla-tion, such as quilts. The more works took on other social functions, the less they were seen as high art and canonical. (Even now, when quilts do sometimes form the subject of traveling exhibitions, they still aren't *canonical* in the way that a painting or a sculpture might be.) As the example of quilts suggests, certain materials just make some things *look* a lot more like art. Until the beginning of the twentieth century, oil paint, bronze, and marble were the stuff of *Art*. Objects that did not use one of the conventional media had a lot more work to do to be included in the canon. Partly through their typical subject matter and materials, the Western canon privileged a certain aesthetic vocabulary, a vocabulary that was alien to other kinds of subject matter and criteria. Quilted, flat decorative patterns made from fabric remnants use neither the materials nor the vocabulary of canonical art.

The museum has also excluded things that weren't collectible. To be col-lectible, a work must not be ephemeral; that is, a work that wears out or is made to be used once and then discarded. Much important art of the twentieth century, however, challenges this concept. For example, the artist Sarah Sze's 1999 *Many a Slip* (Color Plate 4) combines everything from matchsticks to growing grass to oven thermometers, razor blades, fish hooks, and cotton swabs. Part of the as-semblage moves: aquarium pumps bubble; electric fans make things tremble and flutter; and miniature projectors cast images of moving figures onto unlikely surfaces, such as a teaspoon. Designed for a specific place (right down to the creation of a special room and the alteration of the floor and hung by almost in-visible fishing line and tendrils of glue), *Many a Slip* can be photographed to pro-vide a historical record of its existence, but it can never be exhibited again, and it can never become part of the museum's collection. In the past, the ephemeral

[19]Linda Nochlin, "Why Have There Been No Great Women Artists?" in *Women, Art, and Power and Other Essays* (New York: Harper and Row: 1988), 145–178.

nature of her work would have inevitably excluded Sze from the canon. Today, that exclusion gets challenged and is a little less inevitable.

There are several reasons such ephemeral art is now beginning to be found in museums and included in the canon. The first was the introduction of **avant-garde art**—art that deliberately challenged the basic premises of what made for Western art. Avant-garde art frequently challenged the very materials and permanence of art and as such often wasn't collectible. For example, in the early spring of 1960, Jean Tinguely invited guests to the sculpture court of the Museum of Modern Art to view his assemblage *Homage to New York*. There, to the consternation and delight of the audience, he had assembled a Rube-Goldberg-like contraption, which, when it began, belched out smoke, made hideous noises, and gradually self-destructed, creating a fire that eventually was put out by the New York fire department. Although *Homage to New York* could not be collected, it is part of the canon of twentieth-century art, for it raised important questions about what makes for an art object and what the function of the museum is.

The second reason some ephemeral art is now included in the canon is due to the invention of photography, film, and video, which has enabled certain types of work to be documented. In fact, photography is essential to canon formation; things that don't photograph well are less likely to be included in the canon than things that do. Nonetheless, although photography has given work such as Tinguely's a canonical presence that would have been impossible 150 years ago, it is vulnerable, for the less you have a sense of a photograph (or video) being a complete record of that artwork, the more difficult it is for that work to be considered canonical.

Mass-produced work also has historically been excluded from the canon. One reason for this is that such objects aren't rare and valuable—they aren't precious. If one of the goals of the museum is to preserve things, then works that are not rare do not seem to fall naturally under its mandate. Although museums collect one-of-a-kind ceramic objects, they haven't traditionally collected Russell Wright dinnerware from the 1950s. Mass production does not inherently prevent something from being canonical, but, in the museum at least, it never works in its favor.

Conclusion

Given the shifting principles that form the canon, the special interests of the groups that argue about it, what is left out of it, and the changing context that makes some art of other times and cultures almost incomprehensible to the general public, you may ask, Is the canon a good thing? But you may just as well ask if gravity is a good thing. Certainly, the shape of the current canon is not unavoidable. (The works in the current canon are not just the cream that has risen to the top. Oil floats too.) But the *concept* of a canon is unavoidable. Because everybody can't know about everything, choices about what to pay attention to have to be made. A canon comprising every object (or even every art object) that

existed in the world would be incomprehensible. Further, because the people making the choices about the canon are not isolated from a social context, individual choices tend to recur. People are influenced by each other—if they weren't, there would be no canon. The kinds of pressures that make a canon do not mean that individual members of the canon should go unquestioned but only that some kind of canon is inevitable.

That legitimating site of the canon, the museum, is a complicated place whose complications suggest that it is more than just a neutral container for art. The construction of the canon and the exhibition of art is a social activity, an activity that goes beyond the admittedly pleasurable experience of drifting past Monet's water lilies.

But a museum's complications are not all on the surface, articulated clearly in mission statements and informative brochures. Its values can also be found in the conventions that many museums share. A profitable way to understand and deepen one's experience of attending museums is to articulate and understand those conventions that are often taken for granted. And, in fact, many museums have begun to explore and critique those conventions. For example, the Maryland Historical Society in Baltimore, as part of its attempt to expand its audience beyond the white middle class, agreed to have the African American curator and artist Fred Wilson install what has become known as an "intervention." Working with the assistance of the Contemporary Museum of Baltimore, Wilson was given complete access to the historical society's collection (a courageous act on the part of the MHS) and eventually produced the exhibition entitled *Mining the Museum*. Its original run, extending to eleven months between 1992 and 1993, drew large crowds and was "the most popular show in the 150-year history of the MHS."[20]

Using a collection that had been primarily donated by wealthy white patrons, Wilson constructed a series of eight rooms that juxtaposed items from the museum's collection. One room, entitled "Cabinet Making 1820–1910," displayed four Victorian chairs facing another object of nineteenth-century craft: a whipping post (Figure 1.8). In a vitrine entitled "Metalwork, 1723–1880," Wilson included several highly crafted silver serving pieces. Placed in the middle of these precious objects was a pair of iron slave shackles. The show was emotionally gripping; the critic for *Art in America* noted: "As I faced Wilson's unpeopled scenario of punishment as public spectacle, I sensed my complicity as a viewer and was discomfited, as Wilson surely intended."[21]

Using a museum's own categories to show what had been left out of the museum's story of Maryland history and to reveal the museum's complicity with its culture's values, Wilson attempted to rewrite part of the history of Maryland. In an interview with Martha Buskirk in *October* magazine, Wilson commented, "In *Mining the Museum* I'm not trying to say that *this* is the history that you should be paying attention to. I'm just pointing out that, in an environment that

[20]Judith Stein, "Sins of Omission," *Art in America* 81, no. 10 (October 1993): 110.
[21]Stein, "Sins," 113.

Figure 1.8 Fred Wilson, "Cabinet Making 1820–1910," *Mining the Museum,* 1992–1993. Installation, Maryland Historical Society. (© Metro Pictures)

supposedly has *the* history of Maryland, it's possible that there's another history that's not being talked about."[22] Working with a similar agenda, Wilson also installed exhibitions in Warsaw, Poland, in the Indianapolis Museum of Art, and in the Seattle Art Museum. In Seattle, Wilson said he looked at "the linear nature of the floor plan," which took museum goers from the ancient world through the Italian Renaissance to twentieth-century American art. Looking at the galleries that were "not really part of that march of history," Wilson reorganized the museum to make them more central. Wilson comments: "To me it's much more rigorous to look at the museum itself and to pull out relationships that are invisibly there and to make them visible."[23]

The kind of work that Wilson does has become a large part of understanding museums and the history of art. Other curators and artists have done similar work, from the installations of Hans Haacke; to Sophie Calle's *Ghosts,* an intervention at the MoMA; to Joseph Kosuth's 1990 *The Play of the Unmentionable* at the Brooklyn Museum; to the Smithsonian's 1992 show "The West as America: Reinterpreting Images of the Frontier, 1820–1920."

In this chapter we have looked at a familiar institution and made it less familiar: museums look different if you start to wonder why there are fire extinguishers on either side of Rembrandt's *Night Watch* and why so many tourists pose for pictures in front of it. There are ideas at work in a museum that are more than just formal ones and that hint at values other than chronology and innovation. As the next three chapters will show, many of these values have to do with how viewers and artists respond to the unfamiliar.

[22]Martha Buskirk, "Interview with Fred Wilson," *October,* 70 (Fall 1994): 109.
[23]Buskirk, "Interview," 112.

CHAPTER 2

WESTERN ART and OTHER CULTURES
Encountering Difference

Sometimes an artist's representation of another culture tells more about the artist's culture than about the represented culture. The following two narratives, one about the French painter Eugène Delacroix and the other about the Spanish-born artist Pablo Picasso, elucidate the issues involved in representing other cultures. In the first part of this chapter we look at two ways Western artists have represented other cultures: **Orientalism** (a depiction of the Middle East and Asia as exotic, sexualized places) and **primitivism** (the representation of tribal cultures as composed of either noble innocents or violent and sexually threatening peoples).

In late 1827, Delacroix finished his monumental painting *The Death of Sardanapalus* (Color Plate 5). The painting tells the story of the licentious Assyrian king of Nineveh who, as legend goes, when finally defeated by besieging rebels, had all his wives, eunuchs, and horses destroyed before burning himself, his palace, and his possessions. The painting shocked and disturbed contemporary critics for its turbulence, confusion, lack of spatial perspective, and extreme color.

Today, the focus of such a reaction might seem a little odd; viewers today would probably expect the extremely negative reaction to have concerned the subject matter of the painting, its eroticism and violence. But in the early nineteenth century, such subjects were an established convention of French art: images of the Near East (North Africa, Arabia, Persia, India) revealed it as an exotic, foreign, strange place. Delacroix used this "Oriental" subject matter, and, instead of the calm neoclassical images of a sultan's harem preferred by a painter such as Ingres (Figure 2.1), he ratcheted up the emotion. Art historian Lee Johnson describes *The Death of Sardanapalus* as a work in which "many discordant elements [are] uneasily combined," a work in which "the convulsive movement, the

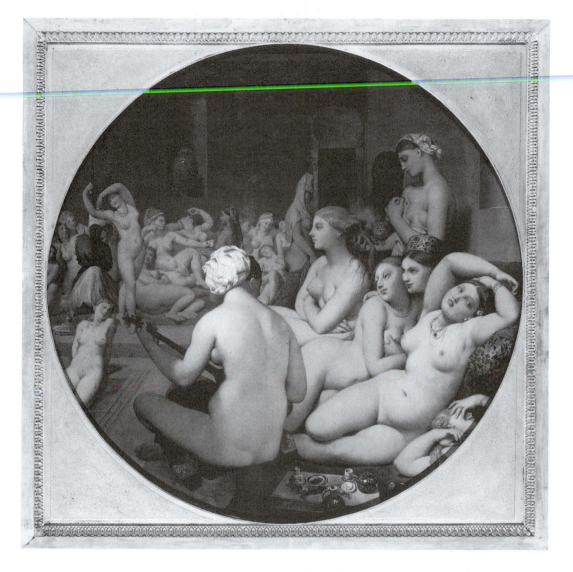

Figure 2.1 Jean-Auguste-Dominique Ingres, *The Turkish Bath*, 1862. Oil on canvas, 108 cm × 108 cm. The Louvre. (© Photo RMN/Gérard Blot)

violence, the frank sensuality, the orientalism, the opulent colouring" all challenged neoclassical restraint.[1]

Not everything about the painting disturbed its original audience; its subject matter was familiar to French audiences. Much of the contemporary fascination with Delacroix's work stemmed from the fact that the "Orient" was a place where European nations were expanding their interests through invasion, colonization, and trade. This and other "Orientalist" works of Delacroix, then, were painted against a complex political backdrop—the French conflict in Algeria and the Turkish-Greek war (Delacroix's brother-in-law was the French ambassador to the sultan of Turkey). Coupled with this larger political setting is Delacroix's firsthand response to the Orient. On his first trip abroad, Delacroix wrote:

> We have landed among the strangest people. The Pasha of the city has received us, surrounded by his soldiers. I would need twenty arms and forty-eight hours in the day to do a passable job of it and give some idea of it all. The Jewish women are admirable. I fear it would be difficult to do other than paint them: they are the pearls of Eden. Our reception has been the most brilliant the place affords. We have been regaled with the most bizarre kind of military music. I am at this moment a man who is dreaming and who sees things that he fears will escape him.[2]

The dreamy exoticism and strangeness of the scene were what compelled him to paint such works as *The Death of Sardanapalus*.

Eighty years later, in March of 1907, Pablo Picasso purchased two ancient Spanish sculptures from the secretary of Guillaume Apollinaire, a French art critic. These Iberian heads, which had been stolen from the Louvre, were far removed from the tradition of realistic representation. They impressed Picasso with their disproportionately large features and their lack of attention to Western ideals of proportion (Figure 2.2). Within six or eight weeks, he began working on what would become *the* momentous, epoch-turning work of modernism, the piece that later would become known as *Les Demoiselles d'Avignon* (Color Plate 6). He dubbed the language of these sculptures into the faces of the second and third figures from the left in that painting.

Working on the painting over a long period of time, Picasso soon encountered another influence. In late spring of the same year, he visited the ethnographic museum at the Palais du Trocadéro, where he had a "revelation" about African art, a revelation that had already inspired his fellow artists Henri Matisse and André Derain. Picasso described the effect of the African art in the following way: "for me the masks were not just sculptures. . . . They were magical objects . . . intercessors . . . against everything—against unknown, threatening spirits. . . . They were weapons—to keep people from being ruled by spirits, to help free

[1]Lee Johnson, *The Paintings of Eugène Delacroix* (Oxford: Oxford University Press, 1981), 116.

[2]Quoted in Frank Anderson Trapp, *The Attainment of Delacroix* (Baltimore and London: The Johns Hopkins University Press, 1971), 113.

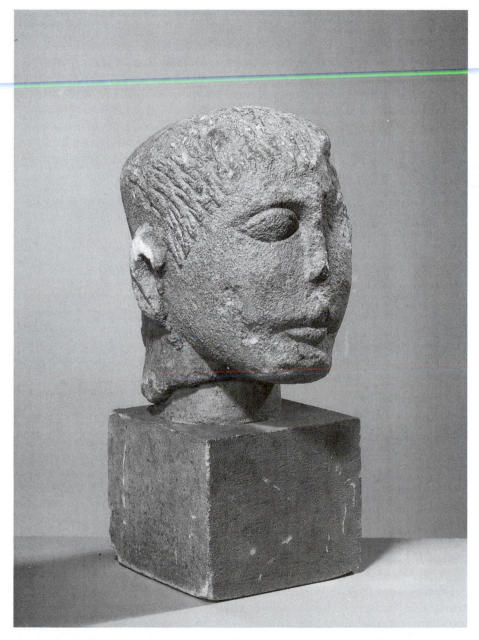

Figure 2.2 *Head of a Man,* Iberian sculpture, 3rd century B.C. White limestone, 20 cm high. Musée de Saint Germain-en-Laye. (© Photo RMN/J. G. Berizzi).

themselves."[3] As he did with the Iberian sculptures, Picasso again used a borrowed vocabulary. This time it was that of the African masks (Figure 2.3): decorative hatching, broad surface planes, and exaggerated features, which were dubbed into the two figures on the far right of *Les Demoiselles.*

To those who saw it, Picasso's resulting work was shocking, not so much because of its subject matter but because of what it looked like, its borrowed formal language of sharp outlines and distorted anatomy, and the "primitive" values this language implied. Picasso's biographer, Roland Penrose, in an enthusiastic but racially charged description that we can now see as highly problematic, gave his interpretation of the primitivism in Picasso's work: "The simplified features of Negro masks express with force the primeval terrors of the jungle, and their ferocious expressions or serene look of comprehension are frequently a reminder of the lost companionship between man and the animal kingdom."[4]

Although Picasso's audiences were shocked by the use of his borrowed vocabulary in Western high art, it was very easy for them, as it was for Penrose, to take this formal language and give it a primitivist meaning. As it was for Delacroix, the stereotypes and their implied racism were part of a larger Western understanding of these other cultures.

Many values accompany Delacroix's and Picasso's borrowing from and representation of these other cultures. Clearly, these works are part of a larger cultural history; in their excessiveness they activate ideas about sex, violence, gender, and hedonism. One of the reasons these two works are so evocative is that they are not isolated examples. They are parts of whole traditions in Western culture, from Tarzan to Charlie Chan, from the *Mikado* to the *Jungle Book,* from televised reports of the Persian Gulf War to analyses of the Rwandan civil war. The cultural history exhibited in the images in and reception of these works is complicated, for it is not just a history of Western Art, it is also a history of other cultures, and to an even greater degree, it is about how artists from Western cultures have understood other cultures, represented them, and used them for their own purposes.

These works, and responses to them, exemplify a larger truth: that people never just *look* at any culture's products (including those from their own culture), for, as Chapter 4 in particular will demonstrate, perception is always goal-directed—people always try to make what they look at *mean* something. When Delacroix looked at Middle Eastern culture and made it the subject of his painting, he didn't just record that culture in some kind of neutral act, he interpreted it. Delacroix didn't just *represent* that culture; he *used* it. And he used it in some predictable ways, ways that his culture instantly understood because such representations were commonplace.

The Delacroix is a classic example of "Orientalism," a way of talking about Eastern cultures that developed in nineteenth-century Europe (and continues to

[3]Quoted in William Rubin, "Piccaso," in *Primitivism in Twentieth Century Art,* vol. 1. (New York: Museum of Modern Art, 1984), 255.

[4]Roland Penrose, *Picasso: His Life and Work,* 3rd ed. (Berkeley and Los Angeles: University of California Press, 1981), 137.

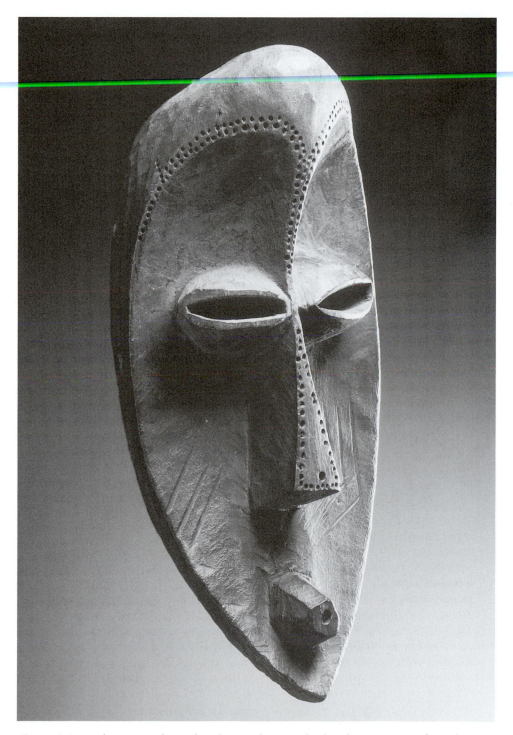

Figure 2.3 Babangi mask, undated. Wood, 14 in. high. The Museum of Modern Art, New York. (Photo P.-A. Ferrazzini, Barbier-Mueller Museum, Geneva)

thrive today) through European domination of Asian and Near Eastern cultures. The values of Orientalism are not innocent, objective representations. Palestinian American Edward Said, who in his career has combined literary, visual, and anthropological analysis, argues that Orientalism is a complicated Western way of thinking about the Eastern world that takes as its subject matter the following assorted topics and attitudes:

> The imagination itself, the whole of India and the Levant, the Biblical texts and the Biblical lands, the spice trade, colonial armies and a long tradition of colonial administrators, a formidable scholarly corpus, innumerable Oriental "experts" and "hands," an Oriental professorate, a complex array of "Oriental" ideas (Oriental despotism, Oriental splendor, cruelty, sensuality), many Eastern sects, philosophies, and wisdoms domesticated for local European use—the list can be extended more or less indefinitely.[5]

Inserted in Said's critique is his description of Western culture's pejorative Orientalist stereotypes: "Oriental despotism, Oriental splendor, cruelty, sensuality." So, Orientalism is a way to talk about Eastern cultures but also a way of talking that works within some questionable parameters. For example, it is much more typical to see Western cultural products that depict Eastern cruelty and sensuality than Eastern kindness and joy. To cite a recent example, according to the December 1998 issue of *Harper's* magazine, American films, when they depict Arabs or Muslims, are 95 percent likely to depict them as "greedy, violent, or dishonest."[6]

Orientalism is only one way the West has found to talk about other cultures. The West has described the art of nonliterate tribal cultures such as those of Africa, South America, and Melanesia as "primitive," and they have meant by that an equally complicated set of values. In her book *Primitive Art in Civilized Places,* the critic Sally Price criticizes Westerners for typically seeing "primitive" cultures "in terms of diabolical rites and superstitions." The Western idea of primitive cultures contrasts "primitive" to "Western cultures." It proposes contrasts "between darkness and enlightenment, depths and heights, fear (superstition) and tranquility (knowledge), and primal urges and civilized behavior (especially in the realm of sexuality)." Primitive culture even becomes for Westerners "the dark expression of irrational terrors."[7] But there is another part to primitivism, seen in the paintings of Paul Gauguin: the idea of the innocent, noble savage, living in a paradise outside of culture (Color Plate 7). Thus, Western ideas of primitivism are twofold: the bloodthirsty cannibal, dancing in frenzied, insatiable ecstasy, and Squanto, patiently teaching American pilgrims how to grow corn.

Although both Orientalism and primitivism are still present in Western culture, they are highly disputed, and many recent critics acknowledge their uneasiness with the terms by putting them in quotation marks (indeed, the term

[5]Edward Said, *Orientalism* (New York: Random House, 1978), 4.
[6]"Harper's Index, *Harper's,* December 1998, 17.
[7]Sally Price, *Primitive Art in Civilized Places* (Chicago: University of Chicago Press, 1989), 38.

tribal is overwhelmingly preferred as a more value-neutral term than *primitive*). Critics hesitate to use either of these terms not only because the terms don't bear scrutiny (that is, these cultures aren't *really* like that; *The Death of Sardanapalus* is more a fantasy than a historical reconstruction) but also because of their negative cultural baggage, the erroneous and sometimes even harmful ideas that typically accompany evocations of the "Orient" or "primitive" cultures.

The Other

To understand how these concepts work and why they are so prickly, we need to examine exactly what *kind* of thinking Orientalism and primitivism are. Many believe that these two concepts promote stereotypes. Stereotypes, though, including the stereotypes of the primitive and the Oriental, are perhaps best first understood as kinds of generalization in which people assume that there are typical characteristics of a group and that individuals within this group do not escape those characterizations. The idiosyncrasies of individuals within the group are less useful than the things that are, apparently, shared. When people use the term *primitive* or *Oriental,* then, they are generalizing, but they are using generalizations that are essentially *wrong* about these cultures and, partly because of these terms' social currency, have bad consequences.

Not all generalizations, however, are bad; in fact, logical argument is impossible without them. For example, it is hard to even imagine a thing called *art* without generalizing. Likewise, it's hard to make any assertions about *cultures* without generalizing. One can't escape generalizations, but one can escape stereotypes.

Let us return to *The Death of Sardanapalus* and *Les Demoiselles d'Avignon* to see how these stereotypes are put into play. *The Death of Sardanapalus* depicts the Middle East as a culture in which life is devalued, where death comes via the capriciousness of a despotic ruler. Sardanapalus is a suicidal fanatic, as are his henchmen. There is a tone of self-indulgence to this bloodbath; Sardanapalus is bored, with his head resting in his hand. Much of this self-indulgence is tied to sex. He has access to a harem, and the killing takes place in his bedroom.

Perhaps the most striking stereotype is the opulence and excess of this scene. Everything is done to an extreme. Jewels spill into the foreground. The fabrics are opulent. The chaos of the scene is also excessive; these are not orderly executions. The ruler has total power, which he can wield in the most extreme, cruel ways. The horses not only have to be killed, they must be killed in front of his eyes. The darkness of the border suggests that this activity continues in the background. Everything about this painting implies that, for Delacroix, the Middle East was a place of unusual cruelty, sexual indulgence, and excessive opulence— all of which neatly illustrate Said's description of Orientalism.

Les Demoiselles d'Avignon uses another culture in a way slightly different from Delacroix's work. Unlike in Delacroix, the other culture (in this case "primitive" culture) becomes incorporated not just into subject matter but into a formal language. With the incorporation of African masks and Iberian sculptures, Picasso uses objects taken from other cultures, and along with the objects comes a formal language that resonates throughout the painting. The use of the masks

ties the formal language of the painting as a whole to stereotypes about primitive cultures. These aren't just masks, they are Picasso's (and the West's) *ideas about* the masks and the cultures from which they originate.

And so, the work uses stereotypes about "primitive" irrationality, sexuality, and threat. There is a primal quality to this work; a crudity of paint, of drawing, of color. The sex in this painting is not depicted as a complicated cultural construction; it is a direct product of elemental passions. The figures themselves are distorted. Are we seeing the back or the front of the figure on the bottom right of the painting? In addition, the figures' angularity can be perceived as threatening. The threat is enhanced by the expressionless and confrontational directness of the faces. Further, the sexuality in this painting is aggressive. The nudity is clearly on display; this is evident in the standard seductive pose of the central figure. Picasso uses the stereotypes associated with the Iberian and African objects and their formal language to make a point about their originating cultures—and to explore the primitive within.

In *The Death of Sardanapalus* and *Les Demoiselles d'Avignon,* the artists use similar conceptual strategies, then. They take cultures that are not their own—and are not well known—but which each artist's culture has some vague ideas about (that the Orient is a place of cruel, sensual despots and that Africa is a place of uninhibited, animalistic passions) and use these ideas to structure their works, ideas that are an example of what cultural critics call the **Other.** Critics define the Other primarily in terms of *difference* and *power.* The Other is a person or group of persons that is seen as radically different from the perceiving, dominant culture—a culture that feels both powerful and threatened by this other person or group. Because the Other is radically different, it produces a kind of crisis: it must be responded to, understood, perhaps even domesticated. Something must be done with it; cultures *use* the Other. Otherness is wide-ranging; it is not limited to the West's use of the primitive and the Orient. Women, homosexuals, Jews, African Americans, Native Americans—all have convincingly argued that they are, or have been, perceived as an Other by a dominating gender, sexual orientation, religion, race, or culture.

The use of the Other by dominant cultures has three striking characteristics. First, it provides a contrast between the culture that is designated by the term and the culture that assigns the term. Second, this contrast is not balanced in its treatment of other cultures; it either ennobles or debases them. Third, the Other reveals more about the dominant culture than about, say, the "real" Orient or the "real" primitive culture. (In fact, some people question whether either of these terms actually refers to something real.)

First, let's look at how the Other provides a contrast. As we have previously noted, Sally Price argues that for Westerners the contrast of primitive culture to Western culture reveals dichotomies between "darkness and enlightenment, depths and heights, fear (superstition) and tranquility (knowledge), and primal urges and civilized behavior."[8] Marianna Torgovnick similarly points out in *Gone Primitive* that primitivism posits the most fundamental contrast, a "we" versus a

[8]Price, *Primitive Art,* 38.

"they."[9] What both these critics are saying is that dominant cultures define the Other in terms of what the dominant cultures are not—or, what they *imagine* they are not.

Such a basic construct (the "we" versus "they") is inevitably value-laden. One half of the contrast is thought to be *better* than the other. Further, it is important to understand that descriptions of, say, primitive culture are not just *views* of primitive culture; these descriptions are always *paired*—that is, they always contrast primitive culture to Western culture. For example, to call primitive art superstitious is to imply that Western culture is enlightened. And for these contrasts to have some heft, it is imperative that the Other be something *outside* of the dominant group. As Said points out, "European culture gained in strength and identity by setting itself off against the Orient."[10]

The idea of the Other does a second thing. As its contrastive structure indicates, reactions to the Other are always extreme: they either demonize or deify the Other. Within primitivism itself, for example, the Polynesian can be the cannibal or the noble savage. Feminists note that women are too often depicted as either virgins or whores. Such extreme conceptualizations, even the deifying ones, dehumanize the Other.

Finally, cultures use the Other to express and deal with their own central, repressed fears or hopes. For example, during the 1950s, alien-invasion movies were an extremely popular genre, and, it could be argued, the aliens in these movies (who were the Other) were a useful device for Americans to deal with their fears of the Soviet bloc. One thing to note is that the Other deals with fears in a variety of ways, sometimes contradictory: it can exorcise, titillate, or perhaps even domesticate our fears and desires. The idea of the Other is not just an attempt to accurately describe a part of the real world, it is a description that has a more complicated job to do, a job that is based more on *our* fears and desires than on whatever may actually be out there in some objective reality.

For example, consider how one might misunderstand the **aesthetics** of another culture (another culture's philosophy of what constitutes good art). After an extensive delineation of the aesthetics of the Yoruba people (a tribe in West Africa), an aesthetics that includes such terms as *ìfarahÒn* (visibility) and *dídón* (luminosity), the art historian R. F. Thompson discusses a Yoruba mask entitled *The Big Nose*. The mask has a "lipless" mouth, which is "a virtual gash framing warty teeth." Thompson asserts that

> Westerners might misread this mask as an expression of cosmic anguish or terror. In point of fact, obliteration of organic detail to the point of bone structure does not denote horror so much as derision—the mask is said to poke fun at the pompous and the vain, mirroring a lack of propriety with a considered indecorousness of expression.[11]

[9]Marianna Torgovnick, *Gone Primitive: Savage Intellects, Modern Lives* (Chicago: University of Chicago Press, 1990), 4.
[10]Said, *Orientalism*, 3.
[11]R. F. Thompson, "Aesthetics in Traditional Africa," *Art News* 66, no. 9 (January 1968): 64–65.

Western viewers don't want to (or perhaps can't) see the humor; they see only terror. This kind of melodramatic overreading of the mask as terror (instead of something more subtle) is a common Western response to primitive art.

Although Western ideas about the Other may not be true and may even be harmful, whole cultures (and not just Western culture) use this kind of intellectual construction to characterize other peoples. It is congruent with dominant cultures' power interests, for it is easier to exploit another people if you believe they are radically different from you. Native Americans, turned into an Other, became suitable targets for colonization. And after their numbers were greatly reduced through genocide, the remaining were transformed, in the imagination of the dominant culture, into noble savages, handy cultural symbols for cities and automobiles.

In fact, one of the most prevalent representations of the Other is the mascot for American high school, university, and professional sports teams. Native American organizations have strenuously objected to, among others things, the name Redskins, the Atlanta Braves' tomahawk chop, and the extreme caricature of Chief Wahoo of the Cleveland Indians.

Consider the halftime dance of the University of Illinois's mythical Chief Illiniwek. As the marching band blares out its Hollywood version of a Native American rhythm and mournful, chantlike melody, Chief, a student in war paint and feathers, dances frenziedly to midfield. He leaps in his beaded moccasins to wild chants from the crowd. As the band begins the alma mater, Chief stands at stoic attention, arms lifted to the sky, in what his supporters characterize as a noble, dignified embodiment of athletic values, and a solemn acknowledgment of all Illini alumni (Figure 2.4). When the music breaks into its fast finale, he dances one last time to the war whoops of enthusiastic fans. The quasi-religious event ends as the band marches off the field. Back to the game.

What is the attraction of such a spectacle? Part of it has to do with the time at which the symbol and name Chief Illiniwek were chosen. It was the 1920s, only a few decades after the last of the Indian battles. To white culture at that time, Native Americans were defeated but still represented danger. Yet at the same time it was common to sentimentalize a foe that was fast disappearing, making available—for a new team that wanted a sense of tradition—instant nostalgia. Over time, Native Americans, resentful of being used for white fantasies, came to criticize the dehumanizing stereotypes, the historical inaccuracies, the bogus attempt to write over genocide. The Other has enormous cultural consequences.

What makes the construction of an Other possible? It is possible because the group that becomes the Other is in some ways unknown to the dominant culture. Additionally, characteristics of the Other are attached to a group that is considered inferior in some crucial way, a group over which the dominant culture has *power*. And because this group is unknown and relatively powerless, the dominant culture can do things to it, and it will not talk back. Those about whom the dominant group speaks do not have an effective voice. The dominant group has control over how the Other is *represented*. It gets the facts wrong because it can get away with it. For example, Chief Illiniwek has a costume, headdress,

Figure 2.4 Chief Illiniwek, University of Illinois at Urbana-Champaign. (Courtesy of the University of Illinois Archives [17,003])

and dance that are modified from Western Plains Indians, yet the Illini tribe was more closely related to the tribes of the East. But until the last two decades, there was no public voice pointing out these inaccuracies and the myths that accompanied them.

The power exercised by any dominant group is multifaceted. Although most people associate power with the military and politics (the institutions of the army, the police, the judiciary, the legislature), there are other, subtler kinds of power: economic, intellectual, religious. As the earlier quotation by Edward Said pointed out, these different forms of power are interrelated, of course: the spice trade, scholarship, colonial armies, and the "complex array of 'Oriental' ideas" are all part of a single package.

In the history of Western art there are numerous historical examples of how these interrelated forms of power have been put to use. Among other things, the great museum collections are more than collections of aesthetically pleasing or significant objects; they are also a history of things acquired through coercion, power, or economic muscle. This history of acquisition has resulted in many of the big museum controversies of the past twenty years. The Greek government, for example, is trying to regain possession of the Elgin marbles from the British Museum, and the Smithsonian Institution is in the process of returning parts of its collection that were taken from Native American gravesites.

Is It Art?

As we have shown, representations of other cultures (such as *The Death of Sardanapalus* and *Les Demoiselles d'Avignon*) are not the only way other cultures enter the Western art world. At times, objects from other cultures are taken out of their original context and put in Western museums, creating a host of conceptual problems.

The initial, most pressing problem is what to call these transplanted objects. Are they called *art?* Do these other cultures have the same concept of art as the West? For many people, answering no to such a question dismisses the whole task of trying to understand the objects of other cultures as art. If other cultures don't have *art* the way we think of it, then the problem of *understanding* the art of another culture goes away. No comparison is possible; one best understands these objects of other cultures by exploring their differences from Western art. Another problem arises from the argument that art is a Western concept and that non-Western cultures don't have art the same way Westerners have art. Critic Sally Price points out that when one claims that only Western culture has art, it makes it possible only for Westerners to make judgments about what is and isn't art.[12]

However, the preceding way of posing and answering the question is not a very useful approach. When people claim, for example, that the Dogon culture

[12]Price, *Primitive Art*, 89.

of Mali does not have art, they typically think of art in the following way: art is a very particular social practice, the practice of aesthetic contemplation that occurs in a context that is freed from the cares of the world. Art is a *pure* thing, unencumbered by utilitarian and other social concerns. According to this position, an object can't very easily be both a functioning door *and* a work of art (Color Plate 8). And so, if one argues that only this pure aesthetic activity is art and that Dogon people do not have this concept of art, they may well be right. Before contact with the West, Dogon people would not have had art museums. They did not make *art*.

However, to make this kind of assertion (that Dogon culture does not have art) is a blandly easy exercise. Art is a broader social practice than the narrow one outlined in the preceding paragraph—it is not just the aesthetic contemplation of high-art artifacts. Further, it is pretty questionable whether even Westerners have much art in this narrow sense. The Ghiberti doors in Florence are both works of art and functional objects. Most Western art has had purposes other than just to be looked at.

In order to broaden the concept of art, perhaps discussion about the art of other cultures should focus on the concept of the aesthetic, and not on the concept of art. That is, Dogon culture may not have art in the narrowest Western sense, but it does have an aesthetic, a sense of what is visually or sensually appropriate to a given work and its context. (Aesthetic contemplation, on the other hand, is the appreciation of a work's visual and sensual elements for their own sake, divorced from the work's function and context.) As Price points out, just because non-Western art does not fit into the tradition of aesthetic contemplation that marks Western high art does not mean that it has no aesthetic sense, that it lacks an aesthetic.[13]

When one talks about the art of other cultures, it is more useful to talk in this broader sense, the aesthetic. The aesthetic is not something that needs to be separated from the world of action. A well-made hammer has an aesthetic dimension, as does an automobile. But even though a hammer can be turned into art in the narrow Western sense and be displayed in a museum, when it does so it loses its functionality (Figure 2.5). At the same time, although a hammer is not an art object when it is being used, it still retains its aesthetic qualities: balance, a comfortable grip, and the sleek angles of the claw opposing the round mass of the head. An African mask is not an art object in the narrow Western sense when it is being used in its original ritual setting, but it does have aesthetic qualities. In fact, all human products have an aesthetic aspect; in even the most everyday object, we can find aesthetic properties.

Thus, everything we call art has an aesthetic dimension; but not everything that has an aesthetic dimension would be called art. In the narrowest Western definition, art is pure; aesthetics, by contrast, can be part of more mixed activities. And most art is a mixed activity, participating in such human concerns as the social, political, intellectual, physical, spiritual, and sexual realms. The

[13]Price, *Primitive Art,* 89.

Figure 2.5 Joseph Kosuth, *One and Three Hammers,* 1965. Hammer, photograph of a hammer, photostat of the definition of a hammer, 24 in. × 55⅜ in. (© 1997 Joseph Kosuth/Artists Rights Society [ARS], New York.)

aesthetic dimension is not everything there is to say about a work—even a work of art.

Formalist and Anthropological Approaches

Museums have two basic ways of exhibiting the objects of other cultures. First, some museums (and this was particularly true early in the twentieth century) emphasize what the object looks like and give only cursory attention to how it may have been used in its original context. This is typically called a **formalist approach.** According to this first view, privileging the study of an object's form (its color, shape, patterns, textures) results in a responsible understanding of what art is *really* about: an object's aesthetic qualities. The second approach, the **anthropological approach,** emphasizes contextual education: how an object fits into a culture's social practices. According to this second view, the more one knows about a culture, the better one can contextualize work from that culture and thus responsibly understand the work.

The conflict between these two approaches is strikingly illustrated by the following story. In 1984 the Museum of Modern Art put on an exhibition entitled "'Primitivism' in 20th-Century Art: Affinity of the Tribal and the Modern." This show prompted the first major, publicly articulated controversy surrounding a conflict that had long existed between formal and anthropological approaches to exhibiting art, to understanding art, to the relationship between the West and tribal cultures. It had enormous consequences for the way the art world thought about displaying the art of other cultures. The ambitious show contained about 150 modern works, representing artists such as Gauguin, Ernst, Klee, Miró, and Picasso. Juxtaposed among these items were about 200 tribal works from North America, Africa, and Oceania. The catalogue for the show was a two-volume, 700-page publication containing over 1,000 illustrations and 19 essays, written by critics of enormous influence. Clearly, this show intended to have some weight.

The show's strategy was to present in the same context and according to Western high-art terms works by both Western twentieth-century artists and non-Western tribal artists. As director of the exhibition William Rubin pointed out in his introduction to the catalogue, the show's "primary purpose [was] the further illumination of modern art."[14] For it to work, the comparison between objects from the differing cultures depended on some shared characteristics, and for the MoMA directors, the most reliably shared characteristics were formal ones. As the exhibition's codirector Kirk Varnedoe asserted in his preface, "we should recall that modernist primitivism ultimately depends on the autonomous force of objects—and especially on the capacity of tribal art to transcend the intentions

[14]Museum of Modern Art, "Modernist Primitivism: An Introduction," in *"Primitivism" in 20th-Century Art: Affinity of the Tribal and the Modern,* ed. William Rubin, vol. 1 (New York: Museum of Modern Art, 1984), 2.

and conditions that first shaped it."[15] In other words, knowing the anthropological context for these tribal works was not the point and was perhaps even beside the point (after all, Picasso had only a vague idea what his African masks were originally used for).

But the directors believed that from this pairing, done on Western terms, might even come an understanding of primitive art. Rubin stated as a secondary goal that these modernist-inspired comparisons "may nevertheless shed some new light even on the Primitive objects."[16]

Easily the most controversial major show of the 1980s (and perhaps the several decades before and since), the MoMA ignited multivoiced responses in the major art journals. The controversy surrounding the exhibition is most clearly demonstrated by the word *affinity* in the show's title: the word implies not just the influence of one culture upon another but kindred pairings of concern between Western art and tribal art from a variety of cultures. Thus, works could have a two-directional affinity with each other, even if it was clear there was no way in which one had influenced the other.

The tribal work became the crux for reaction to the show, the point on which all evaluations of the show hung. In discussions of this show, critics delineated three relevant contexts for the tribal work: the original tribal context, with its ritualistic function; the context in which these works were placed when they had their most relevant affinity (such as Picasso's buying a Grebo mask and hanging it in his studio), with its role in the creation of modernism and the avantgarde; and the 1984 context, with the showing of these two groups of works together in MoMA functioning as a formalist interpretation of art history.

The negative reviews of this show were fierce, and all implied that the consequences of this show were large, ranging beyond the formal premises upon which this show was based. Thomas McEvilley started the argument in *Artforum* with the charge that MoMA intended to keep viewers' responses to the show "closely controlled, both by the book and, in the show itself, by the wall plaques."[17] This control was not innocent, as McEvilley asserted and as James Clifford concurred a few months later in the pages of *Art in America:* the tribal works were presented in a deviously incomplete context. According to Clifford, they were presented just for their formal properties: "At MoMA treating tribal objects as art means excluding the original cultural context. . . . Indeed, an ignorance of cultural context seems almost a precondition for artistic appreciation."[18]

These formalist criteria, pretending neutrality, in fact imposed upon the tribal works a new function. Looking at objects set against a white gallery wall pushed the viewer into a very different activity than participating in a ritualistic

[15]Museum of Modern Art, *"Primitivism,"* x.

[16]Museum of Modern Art, *"Primitivism,"* 2.

[17]Thomas McEvilley, "Doctor Lawyer Indian Chief: ' "Primitivism" in 20th-Century Art' at the Museum of Modern Art in 1984," *Artforum* (Nov 1984): 57.

[18]James Clifford, "Histories of the Tribal and the Modern," *Art in America* 73 (April 1985): 171.

dance. As Clifford grumpily put it: "A three-dimensional Eskimo mask with twelve arms and a number of holes hangs beside a canvas on which Joan Miró has painted colored shapes. The people in New York look at the two objects and see that they are alike" (Figures 2.6 and 2.7).[19]

Clifford argued that in encouraging these kinds of activities MoMA asserted a further principle: these tribal and Western works were not radically different from each other. And he was not completely exaggerating about MoMA's intentions. Making claims for "all great art," director Rubin argued that "If the otherness of the tribal images can broaden our humanity, it is because we have learned to recognize the otherness in ourselves."[20] That vague formulation is, according to Clifford, precisely what was wrong with the MoMA show. According to Clifford, the problem with the MoMA directors was that they too easily asserted that there was a "common quality or essence joining the tribal to the modern."[21] According to MoMA's critics, then, the great unstated project of the show was imperialist. McEvilley would claim that MoMA was "coopting" the Third World,[22] and Clifford groused that "The affinities shown at MoMA are all on modernist terms."[23]

The directors of the show concurred that they did not present a complete context for the tribal works. Writing in *Art in America* in response to his critics, Varnedoe argued that the first purpose of the show was to look at issues "raised by the forms of the objects, rather than with the other kinds of questions that could only be answered by supporting texts about their origins or functions."[24] Characterizing his opponents as claiming that "you really can't know any one thing unless you know everything," Varnedoe went on to assert that knowing the entire context for the tribal objects wasn't necessary; in fact, the MoMA's "selective matching" allowed useful forms of knowledge to surface.[25] The incompleteness allowed for communication between cultures, and in a way that repeated in some form the context of early modernism. Picasso couldn't possibly have known much about the original functions of the African masks, and so he set this knowledge aside. Picasso engaged in "an aggressive recontextualization of tribal objects, out of the (by now largely discredited) web of contextual 'knowledge' that had held them distant and in significant senses invisible, into the volatile taxonomic category of art, then in upheaval."[26] What Varnedoe means by this is that Picasso, by removing these works from the dubious ways of understanding them that existed in 1907, liberated them and let viewers see them as art. According to

[19]Clifford, "Histories," 164.
[20]Museum of Modern Art, "Modernist Primitivism," 23.
[21]Clifford, "Histories," 165.
[22]McEvilley, "Doctor Lawyer," 60.
[23]Clifford, "Histories," 165, 166.
[24]Kirk Varnedoe, "On the Claims and Critics of the Primitivism Show," *Art in America* 73 (May 1985): 11.
[25]Varnedoe, "Claims and Critics," 12.
[26]Varnedoe, "Claims and Critics," 19.

Figure 2.6 Traditional mask, Nunivak Island, Alaska, early twentieth century. Painted wood and feathers, 12⅝ in. high. (Courtesy of the Burke Museum of Natural History and Culture, Catalog #2-2128)

Figure 2.7 Joan Miró, *Carnival of Harlequin,* 1924–1925. Oil on canvas, 26 in. × 36⅝ in. (Albright-Knox Gallery, Buffalo, N.Y. Room of Contemporary Art Fund, 1940)

Varnedoe, Picasso's doing so—and MoMA's repetition of that act—asserts that there is useful sameness between cultures and that to argue against such an assertion results in a lack of communication: "If there's really *no* commensurability between epistemes, and no way to know the Other in our own language, then that is that, and we close the book and hunker down at home."[27]

Problems with Formalist and Anthropological Approaches

In their exhibiting the relationship between modernism and tribal art, MoMA's directors privileged a formalist reading of the artworks. According to the critics, this formalism wasn't always pure formalism; at times, the MoMA's reading of the tribal art had overtones of primitivism. As Marianna Torgovnick claims, Rubin "cannot help but slip" from his formalism into his culture's "emotionally charged image of the primitive."[28] As many critics also pointed out, even trying to consider formal values above all is tainted with the residue of primitivism, suggesting that Western aesthetic values—and not tribal ones—are the inevitable cross-cultural evaluator.

And even if it were possible to achieve formalism's goal of purity, there still are inherent problems with this approach. The first problem is that the whole concept of formalism inherently expresses social values, particularly its belief that art can be separated from life. According to the formalist, it makes sense to look at a medieval altarpiece outside of the context of religious belief and worship. But if it does make sense to do so, this itself is a social belief.

Further, this formalist understanding of an altarpiece is one that some Roman Catholics may find irritatingly incomplete. This incompleteness is the second inherent problem in a formalist approach—that one doesn't know the whole work but just a part of it. And even then one can't know the relation of this small part (a work's formal properties) to the rest of the work's purpose, social function, and history. Formalism is a highly useful but impoverished language. Artworks are reduced when their original use and context are forgotten or ignored, whether they were originally used for revolution or ritual.

In order to make any kind of evaluation of a work, one has to know its function. Imagine, for example, two round, flat objects: one is a plate and one is a shield. How, without some sense of their context, could a critic figure out what is "pure" form for each? Thus, formal qualities of an object are always related to what that object does. Not to know this function results in a flattening out of the work's original richness in a way that is seductive because formalism can seem like such a value-free, effortlessly transferable way to understand art: in looking at art, when context is missing, formalism does the talking.

Third, a belief in the sufficiency of formalism implies that form is a universal language. But such a premise is mistaken; there are many different formal

[27]Varnedoe, "Claims and Critics," 15.
[28]Torgovnick, *Gone Primitive*, 129–130.

languages. Just because two cultures use the same form does not mean that the form carries the same meaning. For example, Sally Price reports on a book on the iconography of Maroon art that argues that a "crescent shaped design element" (designated in Maroon culture by the word for "moon") represents fertility and erotic love—or, more specifically, the penis. She discussed the accuracy of the book's interpretation of Maroon iconography with a group of Maroon people. According to Price, an elderly Maroon, when hearing of the meaning assigned to the crescent shape, "looked somewhat puzzled and declined to comment, but the next day he returned to ask the question that had been bothering him; with apologies for his ignorance on the matter, he wanted to know whether perhaps *white* men's penises took on a curved and pointed shape like that when erect."[29]

In contrast to a formalist approach to art of other cultures, an anthropological approach implies that one can understand a work only in terms of its broader relationship to its culture. For the anthropologist, art is about *doing* things. As such, anthropology answers the "Is it art?" question in an idiosyncratic way. An anthropological approach to art cannot answer this question by an examination of a work's aesthetic qualities. It can only call art something that was used as art in its original context. In doing so, it doesn't ignore aesthetic questions the way a strictly formalist approach ignores social function.

In terms of exhibition practices, an anthropological approach attempts to re-create the context in which a work was first used. According to this view, understanding the context improperly results in giving a work the wrong meaning, such as thinking that Maroons used a crescent shape to refer to the penis, when it really was understood to be symbolic of the moon. On a more extreme level, people who take a work out of context can make it mean anything they want. Consider the earlier example by R. F. Thompson: the mask that Nigerians took as an object of fun was seen by some Westerners as expressing "cosmic anguish or terror."

Not surprisingly, a central tenet of the anthropological approach is education, knowledge. Curators will document the use of the object with photographs, maps, videos, and written descriptions, and they will often put it together with other objects from that culture.

But like the formalist view, the anthropological view can be tainted with the attitudes of primitivism or Orientalism. Sally Price, for example, notes how the following quotation by Thomas McEvilley, in his indictment of the formalist leanings of the MoMA primitivism show, is itself heavily invested in the cliches of primitivism:

> In their native contexts these objects were invested with feelings of awe and dread, not of aesthetic ennoblement. They were seen usually in motion, at night, in closed dark spaces, by flickering torchlight. Their viewers were under the influence of ritual, communal identification feelings, and

[29]Price, *Primitive Art*, 116.

often alcohol or drugs. Above all, they were activated by the presence within or among the objects themselves of the shaman, acting out the usually terrifying power represented by the mask or icon.[30]

More typically, many recent books on primitivism point out how earlier anthropological discussions and exhibitions of the art of other cultures did what today reads like straight primitivism. These earlier discussions and exhibitions *felt* like anthropology, but it was only a simulation; there was a suspicious lack of detail on how these works functioned in their original culture, and instead there was a general invocation of rituals, terrors, sexuality, and the obligatory frenzied dancing. Primitivism, then, is an easy use of stereotypes that *feels* like anthropology.

But, there are inherent or recurrent problems with anthropological approaches to this art, as there are with formalist approaches to the art of other cultures. The problems all have to do with knowledge. First, can we really know everything that we ought to know about another culture? The quick answer is no. Anthropological knowledge is always incomplete; or, at least, it can never be sure that it is complete.

Of course, it is the specialists who have the most at stake in this insistence upon as complete knowledge as possible. Further, when one claims a necessity to know everything about, say, Dogon culture, the possibility of a general audience is eliminated. After all, knowing everything about Dogon culture would take a long time for the nonspecialist. This is Varnedoe's objection to his critics, and Varnedoe proposes a reasonably pragmatic solution: he claims that the impossibility of being complete should not stop one from doing just a piece of it.

Second, the type of knowledge that some forms of anthropology look for is the deep structure underlying a given group's social practices. As art historian Rowland Abiodun points out, anthropologists at times report on things that members of the local culture cannot see or articulate. Italicizing what he sees as problematic, Abiodun quotes anthropologist Edward Evans-Pritchart:

> The social anthropologist *discovers* in a native society what no native can explain to him and what no layman, however conversant with the culture, can perceive—its basic structure. This structure cannot be seen. It is a set of abstractions, each of which, though derived, it is true, from analysis of observed behavior, is *fundamentally an imaginative construct of the anthropologist himself.*[31]

Such talk makes Abiodun nervous, and well it might. That deep knowledge, supplied by someone who is not a member of the originating culture, may be quite different from how a member of a culture understands what is going on. It is hard, in such a context, not to project on the culture one's own interests.

This is not to say that objectivity, though perhaps impossible, should not be an ideal. When one complains about the distorted way Asian culture has been

[30]Quoted in Price, *Primitive Art,* 43.
[31]Rowland Abiodun, "The Dichotomy of Theory and Practice: Blocker's *The Aesthetics of Primitive Art,*" *The Journal of Aesthetic Education* 29, no. 3 (Fall 1995): 39.

received, for example, one is also asserting that some kind of objectivity is possible. Without an ideal of objectivity there is no way to talk about distortion.

A final problem with anthropological understandings of art is that perhaps not all knowledge is legitimate; some knowledge may, in fact, be harmful. Not every culture believes that everything should be the object of knowledge, analysis, and classification. **Ethnographic** knowledge of taboo items or of burial practices may systematize knowledge that the originating culture may well feel should not be the object of "scientific" curiosity. In this light, the Smithsonian Museum has been returning to native tribal groups objects that these groups consider sacred and inappropriate for exhibition and discussion in a museum.

All of the issues in a formalist or anthropological approach are played out in the way museums display the works of other cultures. In the past and sometimes still today, art museums have isolated works to heighten the perception of these works as objects of aesthetic contemplation (Figure 2.8). The objects have been given separate cases, pedestals, or large expanses of wall. Labeling has tended toward the giving of minimal information on a small rectangular label: a generic name for the work, the name of the culture from which it was taken, and perhaps the century in which it was made (if known).

In contrast to formalist displays, anthropological displays include a lot of contextual information. Maps, photographs, documentation—all work not to isolate the object but to surround it with information about its use. In contrast to the cleanness of formalist displays, anthropological displays are cluttered. You have to read, not just look, and the evidence comes from a wide variety of sources (Figure 2.9). Because of issues raised by exhibitions such as the MoMA show, anthropological exhibiting practices are becoming more common in art museums. And such practices are not limited to the art of other cultures. Anthropological exhibiting practices, even in a museum devoted to Western art such as the Orsay, give a more complete picture of Western art practices.

Both formal and anthropological exhibiting practices, though, tend to display Western art much differently than they do the art of other cultures. In looking at the art of other cultures, neither the formal nor the anthropological approach typically identifies individual artists. Although this practice may be due in part to the difficulty of such identification (these are for the most part not signed works), more centrally, neither approach has much incentive to identify individual artists. The artworks of other cultures, particularly the art of nonliterate cultures, are typically seen as communal works, and neither the formal nor the anthropological approach has much built into it to change this emphasis: the formal because such considerations are outside of its domain and the anthropological because the work is an example of an entire culture, not an individual. This stress on the unity of another culture may be offensive to individuals within that culture, implying homogeneity and a lack of development or change.

Freedom from Western Perspectives

One central thing some theorists and anthropologists assert about looking at the art of other cultures is that in order for its viewing to be legitimate or useful, the

Figure 2.8 Example of a formalist display from The Art Institute of Chicago.
(Courtesy of the author)

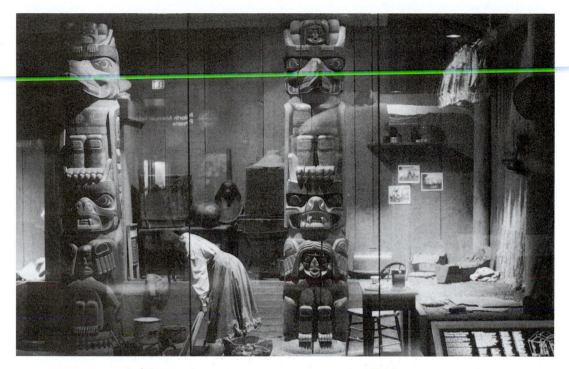

Figure 2.9 Example of an anthropological display from The Field Museum of Chicago. (Courtesy of the author)

viewer needs to be free from Western perspectives. We cannot see (understand) a Dogon door with Western eyes. This idea of freedom from Western perspectives has two basic motivating ideas: the first is a desire to get rid of those individual details that are particular to just Western culture and to find the universal; the second, opposing idea is a need to be free from Western perspectives—not to see the universality, but to see the particularity of another culture.

Those who claim the universality of art argue some version of the following: people are basically alike, and they are able to communicate this similarity with each other. Further, the shared qualities among peoples are not trivial. It's not just that everybody likes ice cream. It's that every culture has something to say about sex, death, survival, power. Carl Sandburg, for example, in his preface to a 1955 photography exhibit at MoMA, wrote: "The first cry of a newborn baby in Chicago or Zamboango, in Amsterdam or Rangoon, has the same pitch and key, each saying, 'I am! I have come through! I belong! I am a member of the Family.'"[32] The underlying claim to such rhapsodies is that *all* cultures think the same certain things are important.

Some people, however, get even more specific in their universal claims: it's not just that all cultures have something to say about sex but that they all have roughly analogous *ideas* about sex. For example, some might assert that not only do all peoples have something to say about sex but that all peoples believe sex is an expression of love. At times, such specific assertions defy rationality. In an interview in the *New York Times,* Susan Vogel, director of New York's Center for African Art, asserted: "Whether you live in Manhattan . . . and are hassled by the giant corporation you work for, or you live in Mali and worry about insects and the drought killing your crops, the gut issues are the same: wealth and health and survival."[33] However, although both the New Yorker and the person from Mali are concerned with wealth, the sense of what each defines as "wealth" (or "survival," for that matter) differs so radically that an unproblematic comparison of them seems absurd.

Both the general and the more specific ideas about universality agree, however, that cross-cultural similarities allow for communication. Implicit in this view is the belief that any comparison of one culture to another demands a fulcrum, a shared point, unless you give one culture complete control of the agenda. "The universal" is that fulcrum upon which people base their cross-cultural comparisons. There has to be *something* that is shared. Universality means that people really can know and understand parts of other cultures.

Those who reject universalism believe that people are products of their cultures, that they don't have essential, shared qualities with other people, and that an individual's identity is profoundly shaped by one's culture. A person's identity cannot be comfortably translated into the terms of another culture. Those who reject universalism turn to what seems a more profitable idea, the

[32]Quoted in Price, *Primitive Art,* 26.
[33]Quoted in Price, *Primitive Art,* 30–31.

idea that perhaps one can best understand another culture by attempting to see through its eyes. Critiquing art of another culture from its own perspective seems a way to avoid the colonial impulse. Of course, it is not completely possible to see another culture through its own eyes unless one is a member of that culture. As soon as one *perfectly* knows another culture, it becomes one's own culture.

As is the case with universalism, there are lots of conceptual problems associated with this attempt to see through the eyes of another culture. First, perhaps even *wanting* to see through the eyes of another culture is possible only in a culture like that of the West, where the idea of ultimate values is no longer widely held. That is, in a postmodern culture many people believe that there is no ultimate truth and that, therefore, seeing through the eyes of another culture is not a risky proposition. If many Westerners believe there is no ultimate truth, they can, for example, *explore* alternative ideas about death without imperiling their own beliefs. But they cannot, in fact, *see* through the eyes of another culture, because that culture really believes these ideas about death. How can people who are skeptical of a belief really see what it means to participate in a given ritual?

Second, it is difficult to articulate the actual bias of one's own culture. Although it seems easy enough to admit that one inevitably has a bias, it is harder to define the content of one's bias. Can people really know something that is inherent, woven into the fabric of their own culture? Is it easier to see these basic things in another culture than it is to see them in one's own culture? For someone used to thinking of time as linear, it is hard to see all the ways in which that linearity shapes one's culture, and it is hard to see how one's commitment to linearity is shaping how one sees another culture. And anyway, if one could remove all of one's specifically Western perspectives, what would be left that one could use to see?

Despite these difficulties, the attraction of seeing through the eyes of another culture remains. Just because complete knowledge is impossible doesn't mean that partial knowledge is also impossible and that one shouldn't attempt to gain some approximation of the perspective of another culture.

But both universalism and seeing through the eyes of another culture can, in their extremes, attempt to combine two different cultures into one glorious new culture. That combining is called **syncretism**. But even syncretism has its problems. First, a belief in syncretism is possible only if one is a relativist about the values that are being combined. Combining Islamic and Coptic art would be attractive if one were neither Christian nor Muslim, but a syncretic mixing of Islamic and Coptic art would no doubt be offensive to both groups.

Second, syncretism is often applied in an odd way, in a paternalistic sense, moving in one direction only. For example, many Westerners see syncretism as highly valuable for their own culture, but they want the cultures they dominate to be "pure." Thus, for many Westerners it is attractive for Western artists to use the idea of shamanism, yet it is much less attractive to see an African culture incorporating into their culture nineteenth-century Christian hymns. This wish for purity is done under the guise of "anticolonialism," but in doing so the West denies other cultures their own cultural dynamism, a dynamism we value in our own.

Conclusion

Thus far, our argument has analyzed problems with the dominant ways of understanding art of other cultures. Serious ethical problems arise when people look at other cultures through stereotypes from within their own culture, stereotypes such as primitivism and Orientalism. But universalism, apparently opposed to stereotypes such as these, can seem either unverifiable or paternalistic. However, neither can we meet the ideal of seeing perfectly through the eyes of another culture. Finally, syncretism is not so much a way of understanding another culture as it is of selectively co-opting it.

But the process of understanding the art of another culture does not necessarily mean that one has to have a theory that all human cultures are essentially the same (universalism) or that all cultures are radically different. In understanding a given object, one doesn't have to choose a theory that will cover one's interactions with all different cultures (indeed, very few viewers have the cultural breadth to make this kind of judgment). Maybe some anthropologists do need to do that, or inevitably want to do that. But that kind of generalization is not required of the ordinary viewer.

As a result, in looking at the art of another culture one needs to be careful, provisional. One might say in a given case, for example, that the Dogon idea of the meaning of symmetry is radically different from that of the West. But it doesn't have to be the case that *no* important correspondences exist between Dogon culture and the West. The same provisionality should be applied to similarities between cultures. At times there are striking similarities between two different cultures, but such similarities do not necessarily imply that basically all human beings are the same.

This provisional understanding of the art of other cultures is a process that entails different kinds of understanding at different stages. For most of us, the point of entry into understanding the art of another culture is an appreciation of its formal properties. The first interaction we have with most art objects is one in which we have little or no knowledge of the context from which the object (or the subject of the artwork) has been taken. That quite naturally leads to a formal appraisal first of all. That's what is immediately intriguing about objects: what they look and feel like. Granted, our initial pleasure in a work's formal values may be incomplete or even wrongheaded, but we should not avoid taking pleasure in a work's formal values simply because we don't know everything there is to know about it.

But to insist on remaining at the formalist level is a problem, for it refuses to respect how this art might have worked in the culture from which it came. We need to discover what those formal values are in service to. At some point we are going to want to know more about a work in its own context. And, of course, we can't do that completely. We can't even do it with Western art. We don't really know what a Rembrandt meant in the seventeenth century. And so, we are limited in what we know about Rembrandt, as well as the art of other cultures. But as long as we know there are limitations to our understanding and as long as the limitations don't have bad consequences (such as perpetuating stereotypes), such limitations don't have to stop us from exploring the art of other cultures.

In works that represent another culture (such as *The Death of Sardanapalus*), the problem is more complicated. As we gain knowledge, we end up negotiating both what the artist was trying to do and the reality he thought he was mediating/representing. Sometimes that results in a loss of pleasure. Maybe we can't look at *The Death of Sardanapalus* in the same way anymore, and maybe there is some sadness (and, for some, anger) in looking at the work, realizing the values in which it is implicated. We can't innocently look at an innocent work anymore. We might still acknowledge that *The Death of Sardanapalus* is formally a great painting and that it had enormous influence on later artists. Maybe the work ends up being on some levels a great painting and on others an ugly one.

In works taken from another culture, the negotiation shifts somewhat. Westerners don't have trouble interpreting many aspects of *The Death of Sardanapalus*: it uses a formal language they recognize and it tells a story that is easily accessible to them. But everyone has trouble interpreting works from other cultures, because without knowing a work's purpose, it's hard to understand its meaning. So when you see work from another culture, try to contextualize it, knowing that this contextualization will be incomplete. You may gain more knowledge over time, and that new knowledge may change how a work functions for you. As with the Yoruba mask, it may no longer be the expression of primal terror but of amusement.

OUTSIDER ART
Encountering Difference Within

Few artists over the last twenty years have captured the imagination of the art world as has Henry Darger. Born in Chicago in 1892, Darger had a very difficult childhood. His mother died when he was young, and after living for a few years with his father, he was committed to the Lincoln Asylum for Feeble-Minded Children. Upon leaving the asylum at 17, he became a dishwasher and janitor. He lived alone for years in a tiny apartment. Having no friends, Darger lived in isolation from society.

Darger, only 5 feet 3 inches tall, was a person of fierce commitments. He attended mass as often as four times a day. Over the years he composed a 5,084-page handwritten autobiography. During the day he could be overheard carrying on dialogues between himself and an imaginary "cranky nun." He was obsessed with inaccurate weather forecasts, about which he filled notebooks. His physical appearance was startling. Art critic Richard Vine reports that

> He wore old eyeglasses tied together with tape and kept his wallet tied to a shoestring that attached to one belt loop. His wardrobe consisted primarily of shirts with torn-off sleeves for summer, a full-length army overcoat and a cap with ear-flaps for winter. Long a dedicated scavenger (sometimes from neighborhood trash cans), he accumulated large collections of twine, eyeglasses, toys, religious pictures and statuettes, Pepto-Bismol bottles, phonograph records and shoes.[1]

Darger, Vine tells us, is the "consummate Outsider" artist.

In 1910, Darger began writing his epic *The Story of the Vivian Girls, in what is known as the Realms of the Unreal, of the Glandeco-Angelinnian War*

[1]Richard Vine, "Thank Heaven for Little Girls," *Art in America* 86, no. 1 (January 1998): 74.

Storm, caused by the Child Slave Rebellion. After ten years of work, the narrative filled 15 hand-bound volumes and 15,145 single-spaced legal pages. *The Vivian Girls* is a story of over-the-top innocence and unbelievable violence, in which goodness eventually wins. Darger then spent the rest of his life illustrating the book. The illustrations were done on large rolls (a typical illustration might measure 22 by 111 inches) on both sides. They combined watercolors, stencils, and collage and featured a world of sometimes-naked hermaphroditic children, sometimes in a state of idyllic purity and sometimes abused and tortured by evil forces (Color Plate 9).

Near the end of his life, Darger entered the Little Sisters of the Poor Home for the Elderly, where he eventually lapsed into a "chin-on-chest stupor" and died.[2] Following Darger's death, his landlord art professor Nathan Lerner discovered the artist's work, which filled his apartment from floor to ceiling. Since then, Darger's illustrations have appeared at London's Hayward gallery, the Chicago Museum of Contemporary Art, New York's Whitney Museum, and other institutions. His work has been marketed through commercial galleries and has been written about in the major art magazines. John Ashbery, considered by many to be the most important living American poet, has published a book-length poem on Darger.

Outsider Art Defined

Within the Western institutions of high art, the way **outsider art** functions is remarkably similar to the way art of other cultures has functioned. Although this chapter looks inward (at art arising from within Western culture) rather than outward (to the art of non-Western cultures), this Western phenomenon of outsider art, too, (1) has a problematic status within the canon, (2) raises questions of relevant aesthetic principles, and (3) is described in terms of Otherness. Although in contemporary visual culture the term *outsider art* is sometimes messily applied to **naive art** (art by an untrained person), **folk art** (the traditional art of a social group), the art of children, and art of the mentally ill, in this chapter we will focus on the central forms of outsider art and put to the side children's art and traditional folk art (such as quilts and Amish barn hexes).

To begin our discussion of how outsider art *functions* (that is, how members of high culture have used it), we must first examine how outsider art has been defined. The definition of outsider art has long been a problem, and not just because it is a fuzzy category, with children artists being a less obvious example of outsider artists than are urban mentally ill artists. There are four central aspects to our definition of outsider art. Most importantly, our definition begins with a biographical premise and only then turns to the supporting characteristics of the work: its formal aspects, its obsessive qualities, and its awkwardness as a category of art.

[2]Vine, "Thank Heaven," 74.

Biography

We begin with biography. The term *outsider art* is an awkward term, for it refers both to the work produced (in the word *art*) and the status of the person who produced it (in the word *outsider*). For the contemporary art world, it is not primarily the appearance of the work that identifies art objects as outsider art but rather the identity of the artist as an outsider. Outsider art is defined by who does it; it can be done only by an outsider.

Outsider art, then, is defined to a large degree by the life of the artist. This life is remarkably similar from artist to artist and has features that are as predictable as the features of medieval saints' lives. Although not all outsider artists have all of the following characteristics, the classic examples of outsider artists have them all and in an extreme form.

The first characteristic is economic. Inevitably, the outsider artist experiences, if not poverty and financial hardship, a precariousness to his or her financial situation. A second characteristic is a lack of education. According to many critics, the outsider artist, by definition, has not studied art and has had minimal general education. A lesser but frequently occurring characteristic is ill health, either physical or psychological.

Critic Joanne Cubbs, skeptical of the way in which high-art culture uses outsider artists, refers to all these characteristics when she explains that outsider artists are "social isolates and eccentrics, religious visionaries, and the inhabitants of mental hospitals, prisons, small rural towns, city slums, and the streets. The merely uneducated, the elderly, and the impoverished are sometimes candidates as well."[3] Although some might bristle at Cubbs's tone, few would argue that she is wrong about the particulars of outsider activists or the hierarchy in which she places them. Henry Darger, thus, is a prime example of the outsider artist. Darger was poor, minimally educated, and socially isolated. His psychological ill health seems to have resulted in something obsessive about the way he made his art—15,000 pages in 15 volumes is not the work of a Sunday afternoon hobbyist.

In fact, the identity of who makes the work is just too important a part of outsider art's definition for style alone to identify something as outsider art. In other words, one can't be interested in outsider art and be a pure formalist, a person who interprets an artwork by its physical attributes alone. For a number of curious reasons, there has never been a New York–based, prosperous, Harvard-educated, psychologically healthy outsider artist.

In short, outside artists are "outside": they are missing those things that put other people nearer the center of culture. And when critics talk about outsider art, they are talking about art that falls outside of the conventions of Western art but is produced within Western culture.

[3]Joanne Cubbs, "Rebels, Mystics, Outcasts," in *The Artist Outsider: Creativity and the Boundaries of Culture,* ed. Michael D. Hall and Eugene W. Metcalf, Jr. (Washington and London: Smithsonian Institution Press, 1994), 85.

All of the characteristics of the outsider artist are based on lack: a lack of financial stability, a lack of training and education, and a lack of psychological well-being. These biographical characteristics all use as central the idea that the outsider artist is isolated from both mainstream Western society and the art world. Many critics imagine that this isolation allows for innocence, an innocence that culture removes from people in the mainstream. These outsiders somehow have *escaped* culture; they are spared its corrupting influences. Despite their suffering, they remain untainted by experience.

The more isolated (and therefore innocent) the artist is, the more extreme her characteristics are, the clearer an example of an outsider artist she is. Thus, folk artists and children artists aren't such great examples of outsider artists; in fact, some people contend that they really aren't in the category at all. Often, the designation outsider artist becomes muddied. Henri Rousseau is clearly a naive artist, but was he isolated in the way a mentally ill person is? It's not clear.

Isolation often can be verified only in terms of biography. And that's why biography is so central to definitions of outsider art. It explains why every book and exhibition catalogue has got to have a shot of the artist standing in front of his or her work, preferably with some surrounding economic/social/psychological indicators (Figure 3.1). We are encouraged to read these photos for indicators of class, education, health, and mental stability. And biography tells us how to look at the work, what to do with it. It tells us if this work is outsider art.

Formal Qualities

Not surprisingly, given the similar backgrounds and approaches that outsider artists share, the biography of outsider artists shapes the look of outsider art. Critic Roger Cardinal, one of the central figures in the "discovery" of outsider art, catalogues the "recurrent features" of outsider art as follows:

> Dense ornamentation, compulsively repeated patterns, metamorphic accumulations; an appearance of instinctive though wayward symmetry; configurations which occupy an equivocal ground *in between* the figurative and the decorative; other configurations which hesitate between representation and an enigmatic calligraphy, or which seek the perfect blending of image and word.[4]

Although few outsider works display all of the characteristics Cardinal lists, almost all display some of them. Take, for example, the painting *New Jerusalem* by the New Orleans artist Sister Gertrude Morgan (Color Plate 10). The artwork is claustrophobic, densely packed with angels, rooms, windows, and doors, repeated to become a dizzy, pulsing pattern. The angels are both representational (that is, they are meant to look like angels) and decorative (they

[4]Roger Cardinal, "Toward an Outsider Aesthetic," in *The Artist Outsider: Creativity and the Boundaries of Culture,* eds. Michael D. Hall and Eugene W. Metcalf, Jr. (Washington and London: Smithsonian Institution Press, 1994), 33–34.

Figure 3.1 The Reverend Howard Finster. (© Jimmy Hedges/Rising Fawn Folk Art, Tennessee)

form a border of repeated shapes). And the painting has a simple, though awkwardly adjusted radial symmetry: the house sits squarely in the middle, surrounded by a border, a halo of angels.

For many, the appearance of outsider art is important in a curiously negative way, for outsider art is partially defined by *not* looking like high art. This visual difference, coupled with all the biographical details, leads some critics to contend that outsider art, by virtue of its being outside the traditions of high art, is in some ways opposed to it. Here, a distinction is necessary. There are two ways of going against the dominant art culture. First is the tradition of the avant-garde artist, who takes something head-on and defies it. When Joel Peter Witkin, a photographer with solid high-art credentials (holding a master of fine arts from the University of New Mexico, showing at the Guggenheim Museum, and being commercially represented by PaceWildensteinMacGill gallery), conflates historical and contemporary sadomasochistic imagery, he deliberately flouts high-art ideals of what should be represented (Figure 3.2).

But there is a second way of going against the dominant culture, and that is to ignore it completely, to not even acknowledge its existence. And that second way seems to be the typical mode of outsider artists. The outsider artist doesn't intentionally defy the history and conventions of art, as compared to the artist Robert Rauschenberg, who in 1959 put a tire around a stuffed Angora goat and entitled the assemblage *Monogram*. Rauschenberg was being defiantly and intentionally avant-garde; unlike Rauschenberg, the outsider artist simply pays no attention to conventions of art history. The outsider artist doesn't particularly worry that "real" paintings are done on rectangular, stretched pieces of canvas and not on the hubcaps of a '63 Ford.

Outsider art is not created in response to the observing pressure of high-art institutions. Although there are reviews of outsider art, these are directed more out to the art world than back to the artist. (After all, few outsider artists subscribe to art journals such as *Artforum* or *Art in America*.) Before they are "discovered," at least, outsider artists generally are not involved in the competitiveness of the art world; they do not make art with their eye on other artists, nor are they conscious of how their work fits into current art fashion.

The outsider artist's lack of attention to the art world has led some art critics in a slightly different, more modest direction. They contend that outsider art is not so much opposed to high art as that it is totally independent, without precedent, new (as we will show later in this chapter, this insistence on originality is necessary for outsider art to take on some of its other ideological functions). But even this more limited account of outsider art's relation to high art is not quite accurate. As Cardinal asserts, outsider artists *are* exposed to visual culture; they just may not be exposed to or pay attention to high-art culture.[5]

It is important, though, to acknowledge that outsider art does not exist in an atemporal realm, innocent of history and technology. In a way, outsider art has its own history of change and perhaps development. For example, outsider

[5]Cardinal, "Outsider Aesthetic," 31.

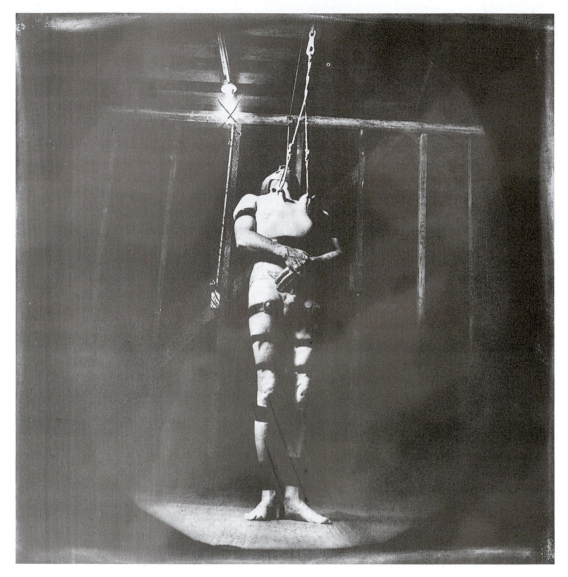

Figure 3.2 Joel Peter Witkin, *Mandan*, 1981. Photograph. (© Joel-Peter Witkin. Courtesy Pace-Wildenstein McGill.)

art of the twentieth century differs from that of the nineteenth century, primarily because of the introduction of new materials, such as bottle caps, masonite, and aluminum foil. And there are changes in technique and process. Chain saws, staplers, and glue guns have altered the expressive language of outsider art.

Obsession

Biography and formal aspects come together in a crucial aspect of outsider art: obsession. "Obsession" is, in fact, a staple of critical vocabulary about outsider art. Critic Roger Manley lists the "obsessive" quality of outsider art as one of its characteristics; Mark Gisbourne describes the "obsessions" of August Walla's iconography; and Allen S. Weiss uses "the vehemence of obsession" as the opening premise for his article on outsider art.[6] By "obsessive," critics mean an impulse that leads to excessive repetition. For example, Simon Rodia, creator of the Watts Towers, covered not one but *nine* towers, one as high as 100 feet, with broken glass and crockery (Color Plate 11). The repetition not only makes the thing that is repeated important for the artist, but it also commands the viewer's attention. The viewer senses that the extravagance seems irresistible to the artist—and perhaps unhealthy. The obsessed artist seems to be living in his own world: solipsistic, antisocial, autistic.

Obsession reveals itself in two ways. It can be seen in an individual piece, such as in the work of Chicago-based Mr. Imagination, who uses thousands of bottle caps to construct a single sculpture (Figure 3.3). Or obsession can be found in seriality, making the same kind of work over and over, as in the work of Garnet McPhail, the Nova Scotian outsider artist who has devoted his artistic energies to carving and painting wooden alligators.

Obsessive works inevitably share an assertive power that eliminates understatement from their aesthetic vocabulary. Under the control of an obsessive impulse, outsider art is typically described as coming directly from the imagination, unmediated by any number of things: art history, social conventions, psychological control, rules of craftsmanship. This sense of an unmediated directness is underscored by such things as awkwardness in execution, selection of unconventional materials, and lack of subtlety. Roger Cardinal, commenting on several outsider artists whom he finds "dense and hermetic," makes the following point: "What is most telling about such works is their total air of assertiveness, which seems intolerant of anything less than our fullest attention."[7]

[6]Roger Manley, quoted in Cardinal, "Outsider Aesthetic," 28; Mark Gisbourne, "Playing Tennis with the King: Visionary Art in Central Europe in the 1960s," in *Parallel Visions: Modern Artists and Outsider Art,* eds. Maurice Tuchman and Carol S. Eliel (Los Angeles and Princeton: Los Angeles County Museum of Art and Princeton University Press, 1992), 183; Allen S. Weiss, "Nostalgia for the Absolute: Obsession and *Art Brut,*" in Tuchman and Eliel, *Parallel Visions*, 280.

[7]Cardinal, "Outsider Aesthetic," 35.

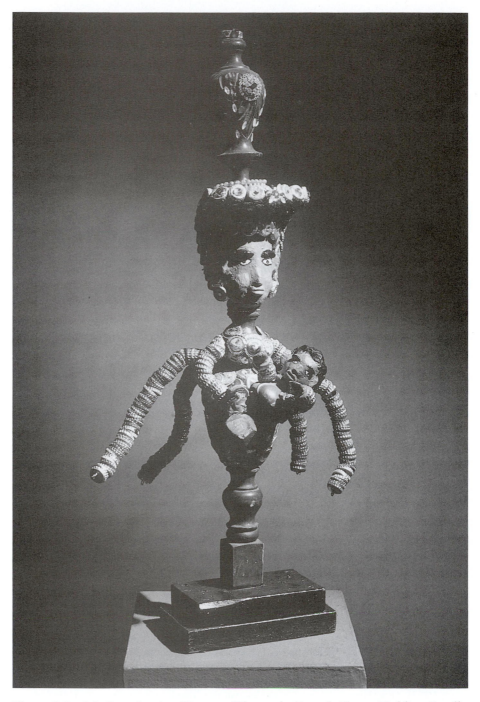

Figure 3.3 Mr. Imagination/Gregory Warmack, *Female Figure Holding Small Figure,* 1999. Mixed media, 39 in. × 18½ in. × 16½ in. Courtesy Carl Hammer Gallery, Chicago. (Courtesy Carl Hammer Gallery.)

Critics interpret these qualities as signaling a sense of conviction, utterly lacking in irony. For example, the well-known Georgia outsider artist Reverend Howard Finster painted the following inscription on one of his paintings:

> My sister who visited me from the dead when I was 3-years old. It seems that the Lord has given her as my guardian angel. She seems to be at the foot of my ladder in space. I believe that everyone has a guardian angel and should listen to their caution: If my body alone should go out in space it could bring back no story. But if my—7-invisible members which is my second Adam of a quickening spirit if it goes out in space it can bring back the facts.[8]

Finster wants the inscription to be understood clearly, directly, unironically. In their sincerity, in their wish to change people's lives, the texts in his artworks oppose any kind of irony (Figure 3.4).

A work is **ironic** when it presents a slippage, when it presents an unsettling tension between what it appears to mean and what it could mean. Irony undermines meaning, sometimes heroically, sometimes slyly. Although there are signals that suggest a work is most profitably read ironically, irony is not an inherent property of an artwork. It is something that viewers do in interacting with an artwork, usually with its encouragement.

For outsider artists, their artworks are *not* ironic, because as soon as an artist has an absolute belief or a single-minded purpose irony stops. Although some outsider art may exhibit a sense of playfulness, it is not the playfulness that says one thing but means another. In the Nova Scotia Gallery of Art stands a rocking chair that Albert Lohnes entirely covered with crocheted yarn—even down to the caning on its back and seat (Figure 3.5). This is not an ironic statement about dematerializing an object, as compared to the way Yale-educated Claes Oldenburg constructed a large vinyl hamburger with just that slippage in mind (Figure 3.6). Lohnes's purpose was to keep the ship's captain from falling out of his chair during rough weather at sea.

Categories

As a final aspect of our definition of outsider art, it makes sense to look at the categories of outsider art. The categories that show up in discussions of outsider art are (1) naive art, (2) art of the mentally ill, (3) folk art, and (4) the art of children. Now, as a cataloguing system, this listing is messy—on the order of the Chinese encyclopedia referred to in Chapter 1. The distinguishing factors of each category are as follow: naive art is defined by the artist's training; art of the mentally ill, by the artist's psychological condition; folk art, by the artist's membership in a particular human culture; and children's art, by the artist's age. And outsider art in general? It seems to be a sociological category, based on the relation

[8]Quoted in Tuchman and Eliel, *Parallel Visions,* 39.

Figure 3.4 Reverend Howard Finster, *Hell Is A Hell Of A Place (#2272)*, 1982. Enamel on wood, 23½ in. × 21 in. (Courtesy of Phyllis Kind Gallery, New York and with permission of the artist.)

Figure 3.5 Albert Lohnes, *Covered Side Chair,* c. 1965. Wool yarn over a wooden chair. Gift of Chris Huntington, NS, 1993. Collection of the Art Gallery of Nova Scotia.

Figure 3.6 Claes Oldenburg, *Floor Burger (Giant Hamburger),* 1962. Painted canvas filled with foam rubber and paper cartons, 52 in. × 84 in. Art Gallery of Ontario, Toronto, Purchase, 1967.

of individuals to society. As they are wont to do, experts argue testily about the appropriateness of these terms.

Perhaps the best way to organize these categories is in terms of isolation and what many see as its result: innocence. In this category of outsider artists, there are good and not-so-good examples of this innocence and, therefore, good and not-so-good examples of outsider art. The folk artist could be considered isolated because folk art is frequently the art of a distinct social group. But the folk artist's isolation (and resulting innocence) is not complete: it is communal, tied to a tradition—skills and images are handed down from one generation to another in quilts, hooked rugs, and weather vanes. In fact, many people would argue whether folk artists are outsiders at all.

Children's art is isolated in that children are not fully integrated participants in society: they can't vote, they are being educated, and they are seen as innocent. But they move out of this isolation as they get older; their isolation is not a permanent thing.

Naive artists are isolated in terms of training. Naive artists also have an innocence about their work. The early-twentieth-century critic Guillaume Apollinaire described Henri Rousseau (the most influential naive artist of early modernism and a friend of Picasso, whose treatment of Rousseau vacillated between fascination and amusement) as "the splendid, childlike old man," who "had the great good fortune to incarnate, as fully as possible, that delicate, ingenuous, elaborate naturalness, combined with playfulness at once knowing and naïve." According to Apollinaire, Rousseau "painted with the purity, the grace, and the consciousness of a primitive," a primitive whose "paintings were made without method, system, or mannerisms." This innocence is so important, in fact, that formal training would destroy the power of the naive artist's work. Apollinaire writes that if Rousseau "had drawn these touching allegories by an act of will, if he had drawn these forms and colors according to a calculated, coolly elaborated system, he would be the most dangerous of men, while in fact he is the most sincere and most candid."[9] Artists such as Rousseau are innocent about what it *takes* to be a great artist. But because they think of themselves as artists (and in the Western tradition of high art), they are not isolated—although the established figures of high art may wonder what they are doing in the same room as them. The more isolated a naive artist is, the better example she is of the outsider artist. (An important side note: the isolated outsider artist is *not* the same as the amateur. Outsider art is not simply a matter of not knowing the rules. Unlike outsider artists, amateurs are people we cannot turn into Others; they are too much like us. Perhaps most notably, they are not innocent and they are aware of their own limitations.)

Finally, the mentally ill artist is psychologically isolated from society and, for obvious reasons, frequently experiences other forms of isolation that contribute

[9]*The Cubist Painters: Aesthetic Meditations 1913*, trans. Lionel Abel (New York: Wittenborn, Schultz, 1949), 39, 40. "The Douanier," in *Apollinaire on Art: Essays and Reviews 1902–1918*, ed. Leroy C. Breunig, trans. Susan Suleiman (New York: Viking, 1972), 336, 339, 348.

to his or her innocence of artistic and cultural conventions. Physical solitude, poverty, and lack of education all intensify the isolation. Because all these forms of isolation tend to cluster in such an individual, the mentally ill artist is typically a clearer example of the outsider artist than is a child.

The Outsider Artist as Other

As the previous section has already hinted at, viewers often attach values to the lives and work of outsider artists (particularly in regard to their isolation and obsession). In this and the following two sections, we will look at viewers' reactions to outsider art in terms of three issues: the Other, irony, and pleasure.

As we discussed in Chapter 2, the Other is radically different from the dominant group. But although they share many characteristics, the Other of outsider art functions in some ways differently from the Other of Orientalism or primitivism. Most notably, the people who make up the Other of outsider art are always isolated individuals. That isolation results in several further differences from primitivism and Orientalism: first, there is no necessity to demonize or debase the outsider because, as an individual, the outsider artist poses no threat to the dominant group; second, this lack of threat means that the outsider is always ennobled and not debased (even if his work may seem threatening, like Darger's). As we will discuss later in this chapter, the language that is used to characterize outsider art is always a heightened language that routinely makes very large claims for outsider art.

Another basic difference between outsider art and that of primitivism or Orientalism has to do with the art's relation to the dominant culture. The Other of outsider art is situated within the culture but is seen as being cultureless. These are exotics who aren't tied to a culture, a local tradition; the shaping influence of this exoticism arises from an isolated individual mind, not a culture. Further, for an outsider art to exist, one must presuppose a central, dominant kind of art, and outsider art is defined in relation to this central art. The critic Lucy Lippard quickly attaches values to this relationship, arguing that even the very name *outsider* is an instance "of an ethnocentric society's negative naming process, based on what is not rather than what is; the margins are defined by the center."[10] As is the Other of primitivism and Orientalism, outsider art is defined in terms of what it is not.

There is a validation that comes from the outsider artist's isolation. Our discussion of the artist as an Other is illuminated by an important historic parallel. The outsider artist has marked similarities with the nonconformist high artist, heroically struggling against the constricting confines of repressed bourgeois culture. There are numerous legends about this kind of artist. Vincent van

[10]Lucy Lippard, "Crossing Into Uncommon Grounds," in *The Artist Outsider: Creativity and the Boundaries of Culture,* eds. Michael D. Hall and Eugene W. Metcalf, Jr. (Washington and London: Smithsonian Institution Press, 1994), 5–6.

Gogh, for example, was apparently rejected by his society, but he struggled on, living a life of defiance to middle-class society. Joanne Cubbs notes that many people see the outsider artist in this light, as "the most extreme example of the Romantic tendency to conflate social and artistic nonconformity, to re-encode social marginality as a willful act of creative individualism."[11] That is, the art world is attracted to outsider artists because they are apparently a lot like van Gogh.

Further, outsider art is seen as pure, in touch with one's emotions, uncluttered by culture. For example, John Maizels, in the preface to his huge *Raw Creation: Outsider Art and Beyond,* argues:

> As children we are all artists, every one of us in the world. As we grow, the creative impetus within us often fades, yet Outsider Art proves the existence of the unending power of human creation. Within each one of us is that spark, that shared universality of human creativity. For some, thankfully, the spark never dies, never finds itself crushed by the norms of adult behavior and cultural conditioning. It is to these natural and intuitive creatures that Outsider Art owes its existence.[12]

This over-the-top romanticizing is remarkably similar to the values attached to primitivism, but it is primitivism for the end of the twentieth century rather than the beginning and for within Western culture rather than directed at another culture.

Reaction to outsider art tends to be extreme, but it is extreme not so much for demonizing it as deifying it. Outsider artists are seen as being special people, with special visionary power. French artist Jean Dubuffet, the major early proponent and theorist of outsider art, characterizes outsider artists in the following way: "Tramps, obstinate visionaries soliloquising, brandishing not diplomas but sticks and crooks, they are the heroes of art, the saints of art."[13]

Any construction of an Other is loaded with the desires and anxieties of the dominant culture, and outsider art is no exception. For example, much of the nostalgia and longing attached to outsider art seems to be colored more by our own desires than by the actual conditions of outsider art. When Dubuffet describes outsiders as "tramps, obstinate visionaries" who are "the heroes of art, the saints of art," he may be expressing his and the art world's desire for an authentic hero rather than describing the autistic world of a suicidal mental patient.

So, outsider art brings something useful to high art. As critic Donald Kuspit argues, the use of outsider art within the institutions of high art allows those associated with high art to gain some valuable moral sheen at bargain basement prices. Outsider art, the "marginal," "is legitimated by the mainstream and the mainstream acquires the aura of authenticity and integrity supposedly innate to the marginal." According to Kuspit, marginal, outsider art gives high art "the

[11]Cubbs, "Rebels," 85.
[12]John Maizels, *Raw Creation: Outsider Art and Beyond* (London: Phaidon, 1996), 7.
[13]Quoted in Cubbs, "Rebels," 85.

exotic look of being at the limit of civilization."[14] Even more strenuous is Joanne Cubbs, who refers to outsider art as an "imaginary pawn," "another manifestation within the art world to seek out and assimilate the marginalized as a means to reinforce and promote its own heretical or outsider posturing."[15] That is, according to Cubbs, the art world uses outsider artists to play at authenticity, innocence, and the moral pleasures of being rejected by "mainstream" society.

Considering the Outsider Artists' Intentions

Perhaps the central difference between the Otherness of outsider art and that of primitivism or Orientalism is the ironic use to which outsider art is put. Here's how irony enters the discourse about outsider art: As stated earlier, there is a common tendency to invest outsider art with values that are not clearly those of the outsider artist. For example, outsider artists are almost universally befuddled by the interest of the high-art community in their work. Usually these artists cannot understand why anyone would pay a lot of money for their work. Further, although their works have a startling directness, outsider artists (with a few megalomaniacal exceptions) make modest claims about their works as *art*— Albert Lohnes made crocheted chairs simply so that people wouldn't slide out of them. Simon Rodia, creator of the Watts Towers, stated of his work: "I had in mind to do something big and I did."[16] Or consider the following response by the Reverend Howard Finster to the question, "Do you think doing art when you're old helps you feel young?"

> I don't even consider bein' an artist, I don't consider bein' an artist at all. My art is visions from God. Like a fellow at this big university wanted to know how'd I do all this. I said, "Do you have a computer?" He said, "Yeah." I said, "Well, God computerizes my brain and it comes right down my hands and comes right out as God computerizes it." I do my art direct from God.[17]

Finster's artworks are intended not as high art but as sermons in paint. And although Henry Darger is heroicized by the art community, unlike most heroic artists, he never showed anybody anything he made. His intentions for his art were very private.

There is, therefore, a noticeable disjunction between how outsider artists talk and think about their work and how critics write about it (as noted in Chapter 2, this disjunction is also present in how anthropologists often describe the art of other cultures). Outsider artists' intentions do not smoothly line up

[14]Quoted in Lippard, "Crossing," 10.
[15]Cubbs, "Rebels," 86.
[16]Quoted in Maizels, *Raw Creation,* 179.
[17]Interview with Norman Girardot and Ricardo Viera. *Art Journal* 53, no. 1 (Spring 1994): 49.

with what many high-art viewers do with outsider work; their purposes and the ways in which their art is often used by the broader culture are in tension. Some of that tension is inevitable. Few of us would share Darger's vision of a violent alien world populated by naked children; few would share Rousseau's belief that he and Picasso split the twentieth century between them; and few would subscribe to the details of Finster's religious visions.

So, the unproblematic acceptance of that outsider world and its innocence is impossible and creates a disjunction between "us" and "them," a disjunction that critics put to some recurring uses, a disjunction whose implications are considerable. As Joanne Cubbs points out,

> Projecting the image of nonconformity and rebellion onto individuals whose lives and work may or may not contest cultural norms and artistic traditions, the discourse of Outsider Art imposes a false intentionality upon some makers, obscures the original subversive content of others, and finally asserts its own hegemony of meaning over those it views as culturally disempowered in a way that is similar to the system it protests.[18]

Mainstream art overpowers outsider art because it controls the discourse and the institutions in which outsider art is seen. Mainstream art makes outsider art mean what it wants it to mean.

A striking example is the discrepancy between the Reverend Howard Finster's sense of his art and the value art insiders attach to it. More than anything else, Finster wants to convert people to his version of Christianity. Finster tells the following story of his 1976 decision to be an artist: "And one day I was workin' on a patch job on a bicycle, and I was rubbin' some white paint on that patch with this finger here, and I looked at the round tip o' my finger, and there was a human face on it. I could see it plain as day. And right then a warm feelin' come over my body, and a voice spoke to me and said 'Paint sacred art.'" For Finster, who recognized that voice as the voice of God, sacred art is the equivalent of preaching, and preaching volubly—over 20,000 works, on anything from canvas to masonite to muffin tins and gourds. All his works are textual, assertive sermons in paint. Finster claims: "Ever' one o' my paintings talks to people. Ever' one o' my paintings has a religious message. Ever' one o' my paintings is a sermon, just like the sermons I used to preach in these churches around here. And when people take one o' my paintings to their house, them messages stays with 'em, and they remember 'em."[19]

But the art world doesn't take seriously Finster's wish to have his art function as "sermons in paint." For one, the critic who transcribed this quotation by Finster made sure that his dialect would be heard loud and clear by sophisticated readers, making Finster seem ignorant. Although virtually all reviewers take Finster's religion seriously as subject matter, they do not take seriously Finster's

[18]Cubbs, "Rebels," 86.
[19]Howard Finster (as told to Tom Patterson), *Howard Finster, Stranger from Another World: Man of Visions Now on This Earth* (New York: Abbeville Press, 1989) 123, 135.

intention: to call them to repentance. And reviewers assume that most people would not take it seriously.

Irony

On some basic levels, mainstream high-art culture puts outsider art to uses that are quite different from how it functions in its original context (which, by the way, is exactly the complaint against primitivism). We first turn to irony. In contrast to how they understand outsider art, critics want to understand the art of other cultures in the way that *these cultures* understand it. Few today would make an ironic interpretation of tribal art. With tribal art and the art of other cultures, it is not that critics know something the tribal cultures don't know, it is that these cultures know something the critics don't know, and the critics want to find out. That is not only aesthetically proper, it is ethically proper. The power relationships, theoretically, are balanced.

With outsider art, by contrast, critics are happy with the idea that they know something outsider artists don't know. So, what happens when critics bring this kind of irony to outsider art? The works appear to be innocent, but viewers read them as subversive. The art appears to be simple, but it is really complex. The works can be serious and earnest, but viewers read them as playful and amusing. This divergence can also be completely reversed: the works are playful, but critics read them as serious. These works are often seen as being seriously subversive of art history and tradition and the art system; of rationality and education; of bourgeois culture; of gender and racial constructions; of the idea that there is a center to art; of Madison Avenue; of the very categories of art. (This subversion doesn't go everywhere: outsider art doesn't subvert such things as heroic individualism or the commodity status of artworks.)

There is a real problem in art insiders bringing an irony to outsider art that the artist is not aware of. When the viewer knows something the artist doesn't know, there is an implicit sense of superiority. And that is exactly the problem many people recognized in the MoMA primitivism show, for it was seen as bringing formalist values to art that did not originally work within the system of formalism. Bringing irony into the alien context of outsider art is equally problematic.

Originality

There is also a gap between the way the mainstream art world tends to look at the newness of outsider art, and the way in which outsider artists might consider it. Outsider artists are undeniably pleased when they create a new object; however, high-art viewers experience a very different kind of thrill at this newness: it is a thrill of something that is new in relation to high art. It is not outsider artists but the *viewers* of their art who experience the thrill of seeing something new, totally alien to high art. Viewers familiar with high art look at outsider art for the unusual, for evidence of difference, which they in turn can conceptualize as opposition. Outsider artists break rules that most artists hold to, and they break them in a way that is impossible for high artists: they are doing it innocently.

Innocence

Further, there is a gap between the supposed innocence of the outsider artist and the sophistication of the mainstream audience. In order for innocence to be an aesthetic value, one necessarily must have a viewer who is not innocent. Nobody knows himself or herself as innocent; innocence is something only someone else can know and notice in another. As soon as you suspect that you are innocent, you are beginning to lose your innocence. So if critics characterize outsider artists as innocents, the critics know something the artists don't know. The innocence of outsider art is celebrated, but it's not something outsider artists can perceive about themselves.

Most critics cling to that innocence. Critics want the "pure" art—art that arises from a condition of innocence. From impulses that are either patronizing or an assertion of power, critics don't want to spoil the naive innocence that allows outsider art to maintain its status as the Other and allows for an ironic gap between the world of the artist and the world of high art. Consequently, for many critics, the answer to the question "Should Mr. Imagination go to art school?" has to be no.

Experiencing Pleasure in Outsider Art

Thus far, the two major issues that we have discussed, the Other and irony, raise serious questions about how one can yet look at outsider art with any kind of pleasure. Both the viewer's construction of the Other and of irony put the viewer in a clear position of power over the outsider artist. Power over an artwork is not necessarily a problem, but the power that arises from the high-art appropriation of outsider art is ethically problematic, having a kind of condescension about it.

Importance

First, many viewers turn outsider artists into the heroes of a story of the viewers' own construction, completely subordinating these artists' original intentions. Outsider works are valuable to these viewers not so much for their pleasure but for what they do. The works are part of a bigger argument that is suspect on several levels. Dubuffet, for example, thought outsider art attacked Western rationality. In contrast, Carlo McCormick, reviewing the work of the Reverend Howard Finster, notes: "As the membrane that separates the subversive, subcultural, antisocial impulse from the organized social body dissolves, the potency of antagonistic, escapist, or psychologically obsessive alien elements beneath our culture's self-perpetuating veneer of health, normalcy and well-being is inevitably reduced."[20] Essentially, through all this turgid prose, McCormick is making this point: Finster's art is good because it exposes contradictions in mainstream culture.

[20]Carlo McCormick, "Review of Howard Finster at PaineWebber," *Artforum* 28 (May 1990): 185.

The problem that erupts from these sorts of claims is that when critics make the work of an outsider artist into a heroic enterprise, a *good* work of art becomes first of all an *important* work of art: it is worth paying attention to for its ideological possibilities. With these kinds of claims, pleasure is a secondary quality, dependent upon the successful heroism of the work. If the heroism fails, there is little pleasure. If we can't make it do good things, we can't like it.

But the opposing way of looking at pleasure is equally problematic. Saying we "just enjoy" outsider art raises other issues. In the first place, pure enjoyment is impossible, for enjoyment is always mediated by specific social circumstances. That is, one enjoys outsider art, but one enjoys it in the comfort and context of a fine-art museum. Or if—as many do—one goes to Henry Darger's apartment to re-create Darger's context, one enters it as a shrine. Each use of outsider art necessarily brings an ideology with it. In fact, the phrase "just enjoy" has its own problems. There is a sense that outsider art is just there, waiting for us to discover it, to liberate it, to bring it to our homes for our pleasure and entertainment. The desire to possess these works smacks of colonialism, in which our discovery of a new outsider artist is a quest for wonders and the exotic.

Sometimes these two things, the overt subordination of pleasure to ideological concerns (to seeing outsider art as important) and the more covert ideologically loaded concept of pleasure, come together in one startling moment. Victor Musgrave, for example, prefaces his catalogue of outsider art with the awe reserved for the nineteenth-century Wunderkammer (discussed in Chapter 1) and with the strenuous hype of the circus sideshow:

> Here is an art without precedent. It offers an orphic journey to the depths of the human psyche, filled with amazing incident, overspilling with feeling and emotion yet always disciplined by superlative technical resources.
>
> It is as if we have abruptly stumbled upon a secret race of creative giants inhabiting a land we always knew existed but of which we had received only glimmers and intimations. We may well feel impelled to survey their work with an appropriate humbleness for they seem to have penetrated the most profound and mysterious recesses of the imagination in a way that the Surrealists would have envied.
>
> Bereft of historical guidelines and cultural norms the spectator must rely on his own perceptions and sensibilities. For some this may be a disconcerting experience, for others the beginning of an exultant pilgrimage into the unexpected. When so much contemporary art is bland and supine in the well-crafted chains of its own making, the Outsiders give a great and joyous shout: "We are artists, we are explorers, we go where no man has trod before. Follow us if you dare!"[21]

Undoubtedly Musgrave feels real pleasure, but he presents the outsider artist as the primitive Captain of the USS *Enterprise*, boldly going where no man has gone before.

[21]Victor Musgrave, preface to *Outsiders: An Art Without Precedent or Tradition* (London: Arts Council of Great Britain, 1979), 8.

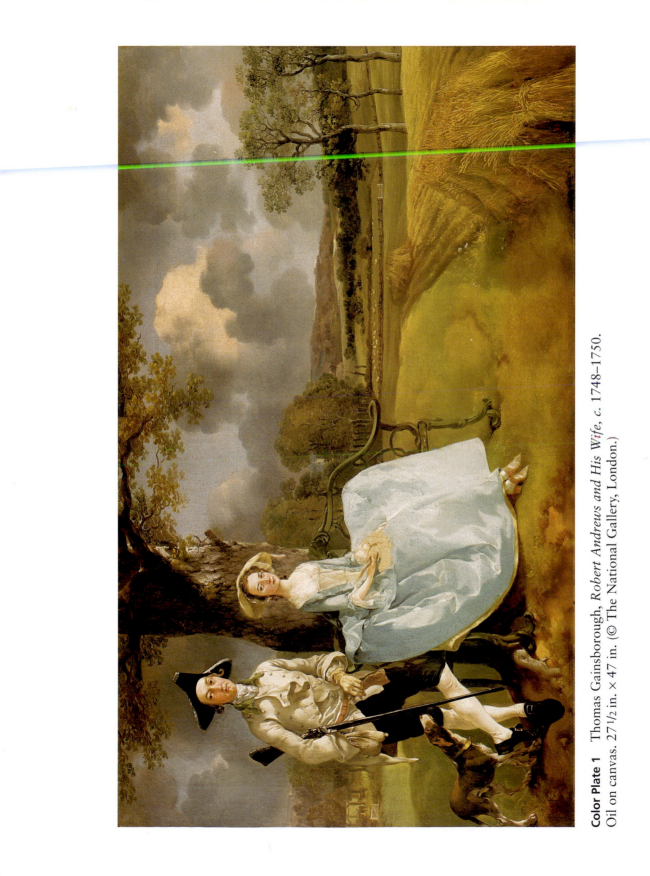

Color Plate 1 Thomas Gainsborough, *Robert Andrews and His Wife*, c. 1748–1750. Oil on canvas. 27½ in. × 47 in. (© The National Gallery, London.)

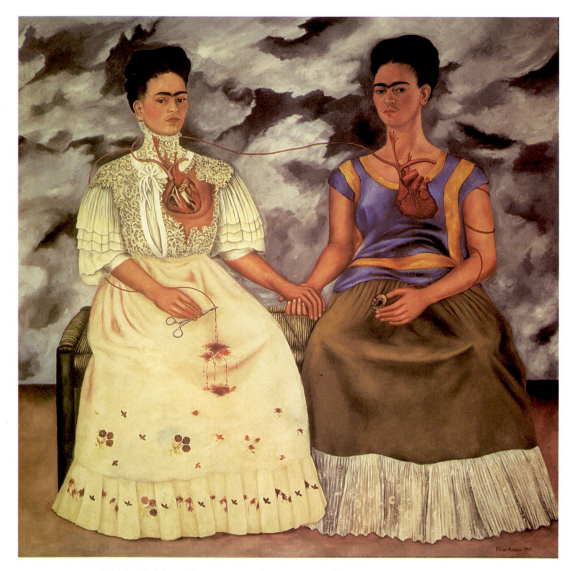

Color Plate 2 Frida Kahlo, *The Two Fridas*, 1939. Oil on canvas, 173.5 cm × 173 cm. (© Museo de Arte Moderno, Mexico. Reproduction authorized by the Instituto Nacional de Bellas Artes y Literatura.)

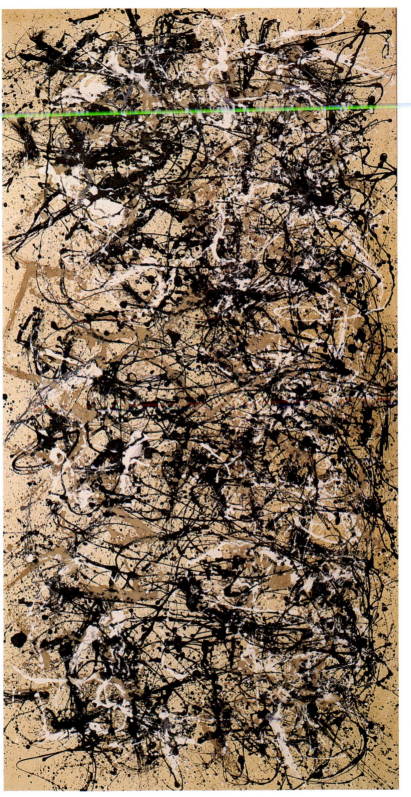

Color Plate 3 Jackson Pollock, *Autumn Rhythm (Number 30)*, 1950. Oil on canvas, 8 ft. 10½ in. × 17 ft. 8 in. The Metropolitan Museum of Art, George A. Hearn Fund, 1957. (57.92). (Photograph © 1998 The Metropolitan Museum of Art. © 2000 Pollock-Krasner Foundation/Artists Rights Society (ARS), New York.)

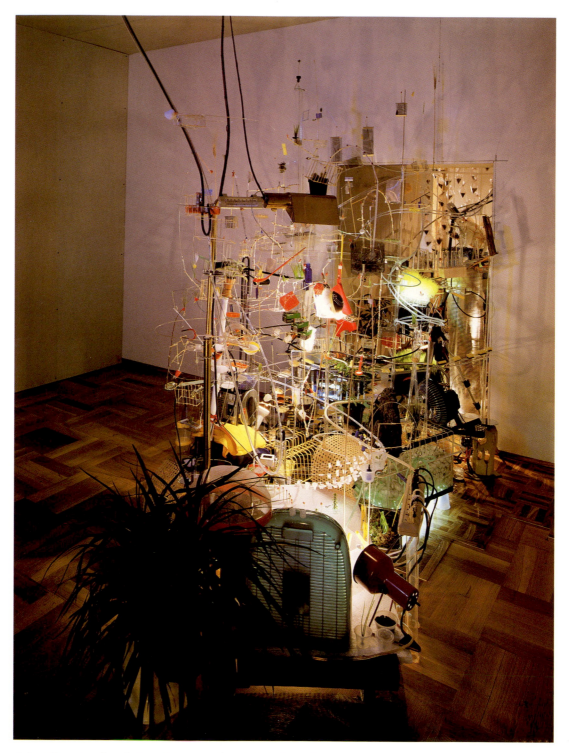

Color Plate 4 Sarah Sze, *Many a Slip*, 1999. Installation at the Museum of Contemporary Art, Chicago. (Photo courtesy of the Marianne Boesky Gallery, New York.)

Color Plate 5 Eugène Delacroix, *The Death of Sardinopolous*, 1827–1828. Oil on canvas, 395 cm × 495 cm. The Louvre. (© Photo RMN/Hervé Lewandowski.)

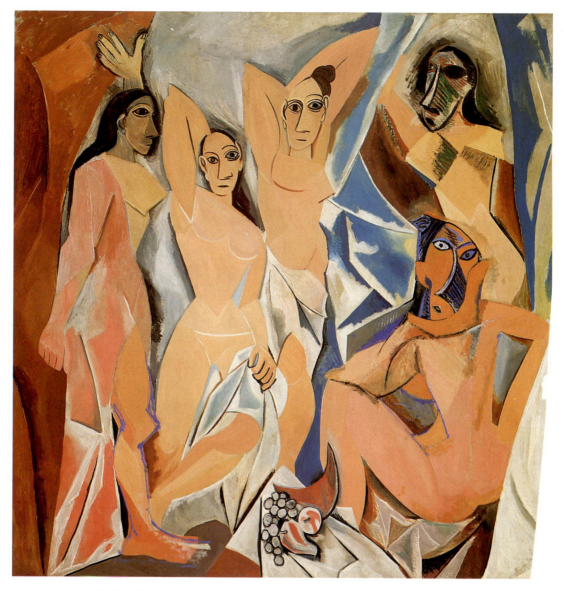

Color Plate 6 Pablo Picasso, *Les Demoiselles d'Avignon*, 1907. Oil on canvas, 8 ft. × 7 ft. 8 in. (243.9 cm × 233.7 cm). The Museum of Modern Art, New York. Acquired through the Lillie P. Bliss Bequest. (Photograph © 1999 The Museum of Modern Art. © 2000 Estate of Pablo Picasso/Artists Rights Society (ARS), New York.)

Color Plate 7 Paul Gauguin, *Day of the Gods* (*Mahana No Atua*), 1894. Oil on canvas, 27 in. × 36 in. (68.3 cm × 91.5 cm), Helen Birch-Bartlett Memorial Collection, 1926.198. (Photograph © 2000 The Art Institute of Chicago. All rights reserved.)

Color Plate 10 Sister Gertrude Morgan, *New Jerusalem*, 1972. Acrylic and ink on paper, 22 in. × 28 in. From the collection of Dr. Kurt Gitter and Alice Rae Yelen.

Color Plate 11 Simon Rodia, *Watts Towers*, 1921–1954. Mixed media in landscape, Los Angeles. (Photo courtesy of the author.)

Color Plate 12 Hollis Sigler, *Sometimes It's a Matter of Just Holdin' On*, 1994. Oil on canvas with painted wood frame, 42 in. × 42 in. (Courtesy of the artist and Carl Hammer Gallery.)

Color Plate 13 Ann Hamilton, *the capacity of absorption*, 1988–1989. Installation at The Museum of Contemporary Art, Los Angeles. (Photo by Wayne McCall. Courtesy of Sean Kelly Gallery, New York.)

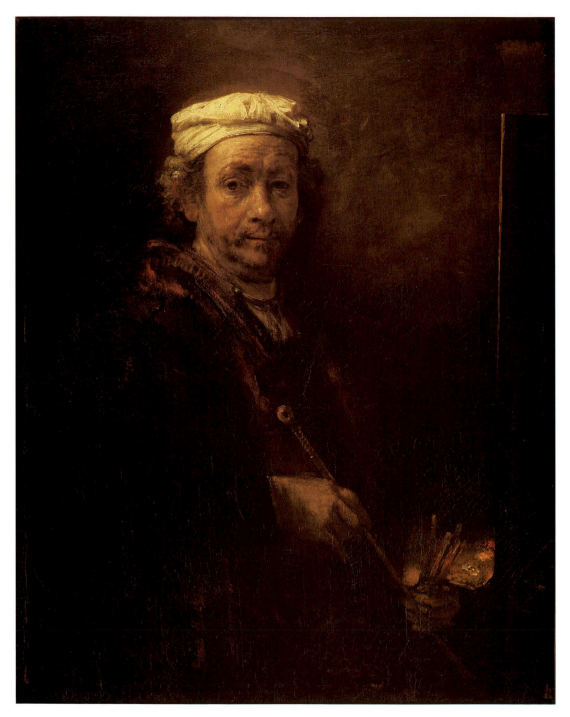

Color Plate 14 Rembrandt van Rijn, *Self-portrait at the Easel,* 1660. Oil on canvas, 111 cm × 90 cm. The Louvre. (© Photo RMN/Hervé Lewandowski.)

Color Plate 15 Joseph Albers, *Homage to the Square: Apparition*, 1959. Oil on Masonite. 47 1/2 in. × 47 1/2 in. (120.6 cm × 120.6 cm). Solomon R. Guggenheim Museum, New York. 61.1590. (Photograph by David Heald © The Solomon R. Guggenheim Foundation, New York. © 2000 The Josef and Anni Albers Foundation/Artists Rights Society (ARS), New York.)

Color Plate 16 Sigmar Polke, *Der Ritter (Knight),* 1988. Artificial resin and acrylic on fabric, 118 1/8 in. × 88 9/16 in. (300 cm × 225 cm). ARC, Musée d'Art Moderne de la Ville de Paris. (© Phototheque des Musées de la Ville de Paris/Trocaz J-Y.)

Among the difficulties of writing about outsider art, not to mention collecting or looking at it, pleasure is a central problem. Is it legitimate to both know something the outsider artist doesn't know and still enjoy her work? Is it necessarily exploitative or patronizing to enjoy outsider work? Although the critical problem is easy to identify, the dilemma from which it arises is not easy to escape. After all, anybody who writes about outsider art or views it in a gallery occupies a different social and intellectual position from the outsider. Inevitably, then, we don't get our pleasure from occupying the same space as the artist.

Amazement

The solution to the problem of pleasure is found in a simple approach: viewers need to take into account the outsider artists' goals for their work. This is not to say that viewers have to be completely directed by the outsider artist's intentions, but to disregard them would be a problem. We can't look at outsider art totally on its own terms, but neither can we force ours to be the only terms. The heroicizing of an Other or irony shouldn't be the automatic response.

An attitude that may be broad enough to recognize both the original context of these works and the viewer's context is amazement—but amazement without hype. *Amazement* is an experiential, highly subjective word that is not tied to specific artistic stances. And amazement is a more general experiential category than, say, the sublime. We can experience amazement at an artist's psychological obsession as well as his particularly inventive use of bottle caps. Further, amazement is unstable; we have no idea where it will go and what its end point will be. It does not necessarily lead to heroicizing or irony.

One aspect of amazed pleasure is the viewer's recognition that she or he can't make work like outsider art. Biography, then, is still central to understanding and receiving pleasure from outsider art. But all the viewer needs of this biography are indications that the creator of a particular work has had a life that is inaccessible to the viewer. A work such as Nellie Mae Rowe's *Untitled (Nellie in Her Yard)* may establish this biographical inaccessibility on any number of levels (Figure 3.7). Many viewers may note that Rowe has addressed a self-portrait in a landscape with an unfamiliar approach, from the odd scale of the nonhuman figures, to the materials used, to the work's oscillation between decorative and figurative elements. Rowe has an idiosyncratic way of conceptualizing this self-portrait that seems to be somewhat isolated and to come from outside mainstream art culture, a conceptualizing that is probably unfamiliar, perhaps even shocking to viewers. And this difference is not just a technical issue but one that has more to do with her entire way of looking at the world in relation to her art. This work has been produced by a mind *different* from that of her typical viewers.

Although initially this assertion of difference may sound like the melodramatic assertions of Victor Musgrave, quoted earlier, our idea of amazement has, we hope, a self-awareness that Musgrave lacks, for we believe it needs to be amazement without hype. When amazement is overblown, some real problems arise. When Musgrave—as a typical but perhaps more poetic writer than other critics—describes outsider art as an "orphic journey to the depths of the human

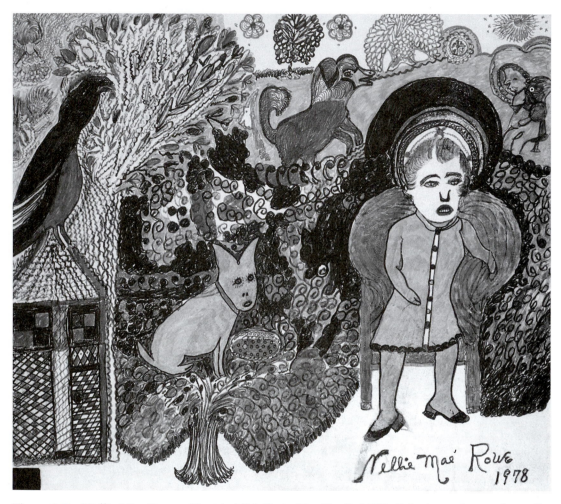

Figure 3.7 Nellie Mae Rowe, *Untitled (Nellie in Her Yard)*, 1978. Felt-tip marker and pencil on foamcore, 17½ in. × 20 in. Collection of the Museum of American Folk Art, New York. Gift of Judith Alexander. 1997.05.01.

psyche," when he describes outsider artists as "a secret race of creative giants" who have "penetrated the most profound and mysterious recesses of the imagination," when he exhorts us to follow them if we dare, he loads onto outsider art too much conceptual and ideological weight. As we have shown throughout this chapter, this romanticization dehumanizes outsider artists, making Otherness inevitable.

Avoiding hype shouldn't be that hard to do. We smile knowingly at overblown amazement; we recognize it as hype. Consider Giorgio Vasari's late 1500s portrayal of Leonardo da Vinci:

> The greatest gifts are often seen, in the course of nature, rained by celestial influences on human creatures; and sometimes, in supernatural fashion, beauty, grace, and talent are united beyond measure in one single person, in a manner that to whatever such a one turns his attention, his every action is so divine, that, surpassing all other men, it makes itself clearly known as a thing bestowed by God (as it is), and not acquired by human art. This was seen by all mankind in Leonardo da Vinci, in whom, besides a beauty of body never sufficiently extolled, there was an infinite grace in all his actions; and so great was his genius, and such its growth, that to whatever difficulties he turned his mind, he solved them with ease.[22]

If a critic today wrote this way about Leonardo, he or she wouldn't get published. This hype has disappeared from discussions of high art, and it should also disappear from discussions of outsider art.

Lowering the rhetorical volume about outsider art while retaining one's amazement is both necessary and possible. Undeniably, people enjoy the experience of being amazed at things. But just because such art confronts us with something we can't know (and thus makes the work "difficult," an issue we will discuss in Chapter 4), it doesn't mean we have to give it the qualities of an Other. When the rhetoric is lowered, amazement does not presuppose an agenda of Otherness or primitivism.

This pleasurable amazement does not have to be patronizing or deifying. It's neither hero worship nor the thrill of driving slowly past a particularly nasty accident on the expressway. The thrill is not in seeing the pain (if indeed there is any); it is in seeing what another human being can make of this stuff, a human being different from us.

In fact, there is an aspect of this pleasure that at first glance seems embarrassingly banal, the reaction that "wow, he really used a lot of bottle caps. Where did he get them all?" We take the same banal pleasure in high art when we notice, for example, how many brush strokes Andrew Wyeth uses to paint a field of dead grass. This simple pleasure implies that the work was made by an idiosyncratic individual. And to value that kind of eccentricity is not necessarily a patronizing thing: Caravaggio, Rembrandt, Whistler, O'Keeffe are all eccentric in some crucial

[22]Giorgio Vasari, *Lives of the Most Eminent Painters, Sculptors and Architects,* trans. Gaston Du C. de Vere (New York: Harry N. Abrams, 1979), 778.

way that affects what their art looks like and the characteristics of the pleasure that we receive from it. And just as we are *amazed* at outsider art, so we are amazed at high art, too. The sheen of Vermeer's interiors, the audacity of Jeff Koons's stainless steel bunny, the representational complexities of Cindy Sherman's film stills—all these elicit amazement. Without amazement, our experience of all forms of art is impoverished.

Faux Naive Art

Given the extremely interesting issues raised by outsider art, it was perhaps inevitable that mainstream artists became interested in exploring how outsider art might shape their own art. Artist Jean Dubuffet was the earliest major proponent of what has become known as **faux** (that is, false) **naive art**—high art that takes on the look of outsider art. Advocating what he called *art brut* (another term for outsider art), Dubuffet started to make art that looked like outsider art. He believed that this art was more authentic, more in touch with what it is to be human, because the veneer of civilization (the conventions of Western art) had been removed. For Dubuffet, his naive art was a way of stripping away Western conventions—such as theories of perspective and space—that get in the way of authenticity. By painting in a naive style, Dubuffet attempted to get art back to what it really is and to deal with direct experience.

Many artists since then have adopted similar approaches, culminating, perhaps, in the 1992–1993 show "Parallel Visions: Modern Artists and Outsider Art," a major exhibition that showed both outsider artists and mainstream artists who were influenced by them. What are the issues that arise when a highly trained artist makes artworks that look naive, untrained? Consider the work of the Chicago artist Hollis Sigler. With a bachelor of fine arts from the Moore College of Art in Philadelphia and a master of fine arts from the School of the Art Institute of Chicago (two leading art schools), Sigler has attempted in her art what one critic refers to as "Taking advantage of the inherent tension between a deliberately naïve style and a sophisticated combination of narration and symbolism."[23] Consider her *Sometimes It's a Matter of Just Holdin' On* (Color Plate 12). The folksy title is just the first indication that Sigler is adopting an outsider visual vocabulary. The clunky symmetry of the work, its flatness, the simplification of the tree's structure, and the intentional perspective error of the house on the left push this work to the look of outsider art. In addition, Sigler has applied paint very awkwardly, perhaps most notably in the obsessively painted sky, with its jittery strokes radiating outward from the central tree. The decoratively painted frame and the apocalyptic imagery are yet other echoes of outsider art.

In a work such as this, is Hollis Sigler appropriating what many would see as the authenticity of outsider art? its innocence? its Otherness? Is it deceptive

[23]Staci Boris, *Hollis Sigler: The Breast Cancer Journal* (Chicago: Museum of Contemporary Art, 1994), 8.

for Sigler to deliberately take on an untrained look, given that she has the ability to use all of the skills of a highly trained artist? Can someone regain a "lost" innocence? Perhaps not, but given the emphasis that biography has on understanding outsider art, it is inevitable that such questions arise.

These questions are not easy to answer. We need to acknowledge that in work such as Sigler's the style is *deliberately* naive and that this deliberateness creates a tension between the naive vocabulary and the knowingness. But this type of work raises a problem. As soon as we call it a deliberate style, or as soon as there is a consciousness of naivete on the part of the artist, the artist and the work are no longer naive. Faux naive art itself becomes a set of conventions. As soon as one says a work is in a naive *style,* one separates the faux naive work from work that is actually naive. Such a separation between the vocabulary of outsider art and its "authenticity" is not congenial to most trained artists who paint in a naive style; it poses a difficulty for the viewer as well.

Irony is yet another complicated issue. Although in faux naive art there isn't the problem of the viewer's knowing something that the artist doesn't (as in the work of Reverend Howard Finster), faux naive artists aren't typically being ironic about their outsider style. They consider their use of outsider style to be authentic, inevitable.

All of these issues result in art that is very complex. There is a disorienting sense about many of these works. For example, one can't always be sure that a faux naive artist hasn't drifted into some real kind of naivete or Otherness. One of the pleasures of faux naive work is negotiating the tension that arises from these kinds of issues—and the amazement that one feels in the presence of visually compelling work that is stripped of many conventions.

From the Outside to the Inside

While some artists such as Sigler have had very interesting careers as faux naives, the career of the outsider artist who attempts to become "mainstream" is a little more perilous. After a mixed career as a bouncer, boxer, brawler, and thief, and following his release from prison, the Chicagoan Tony Fitzpatrick began to draw with colored pencils on small, framed children's slates (Figure 3.8). His only art "training" consisted of dating an art student at the School of the Art Institute of Chicago. After his parole, on a visit to New York City to visit his former girlfriend, Fitzpatrick brought along his slates. During the course of his visit, he decided to try and sell them. After all, New York was the art capital of the world. Fitzpatrick set up his display in Washington Square and waited for buyers. Late in the day he sold two works to a "skinny guy with glasses." The next day the buyer returned with a friend, who also bought work. These buyers, the 1980s celebrity artists Keith Haring and Jean-Michael Basquiat, took Fitzpatrick to an East Village gallery, and his career as an outsider artist was launched.

As an artist Fitzpatrick did well in New York and internationally, and he occupied a position of status in Chicago, a city with a reputation for revering its outsider artists. His galleries marketed him as an outsider, but Fitzpatrick, who

Figure 3.8 Tony Fitzpatrick, *The Broken Starling*, 1999. Etching and aquatint, 6 in. × 5 in. (Courtesy of the artist.)

by this time had a dual career as an actor, chafed at the designation "outsider." He did not think that "outsider" accurately characterized him or his work. He was more than that. He had acted in movies and on TV and had written and acted in an award-winning play. Socially, he was not an outsider; he was a part of the city's cultural community.

In the midst of his irritation, Fitzpatrick "discovered" printmaking. Printmaking, and in particular the technique of etching that Fitzpatrick adopted, is a highly self-conscious high-art medium. In today's terms, printmaking epitomizes traditional art, with its arcane craft, its specialized art vocabulary, and its detailed, intimate images. Fitzpatrick approached etching the way a tattoo artist approaches skin. In fact his images (their subject matter, line quality, and color) draw from the dangerous desires, the fetish symbols, and the personal obsessions of the tattoo.

But such printmaking, because of the sophistication of the medium alone, by definition is not marketable as outsider art. And Fitzpatrick's dealers wanted none of it. One by one, he lost his gallery representation. Fitzpatrick, though, had not changed the meaning of his images or the way he viewed himself as an artist. He had always thought of himself as just an artist. Resentful of the designation "outsider" and its implied Otherness, Fitzpatrick eventually found new galleries—the kind that didn't care if the work was an etching and that didn't think of him as an outsider.

As this story of Tony Fitzpatrick demonstrates, the category of "outsider" can be easily blurred. It is a messy and somewhat arbitrary designation. Outsider art is a conceptual construct, often used in the service of the art market. It is not primarily interested in the growth of its artists. The insistence that Fitzpatrick be marketed as an outsider, although initially seeming plausible, became increasingly forced over the course of his career. It resulted in an Otherness that Fitzpatrick rejected. And once Fitzpatrick apparently lost his "innocence," his career almost ended.

Conclusion

Outsider art gets its energy from a very charged relationship between the artwork and its mainstream audience. This energy arises first from the primary aspect that defines outsider art: that is, the outsider artist's biography, which sets him or her apart from the mainstream audience. But outsider artists do not rebel against mainstream culture so much as they work outside of the conventions of Western art. Even though they evade the conventions of Western high art, the formal conventions of outsider art are, to a certain extent, predictable and are most clearly seen in its obsessive qualities. Many art "insiders," noticing the way outsider art looks and recognizing its makers' social status, use language and conceptual strategies that end up characterizing outsider artists as the Other. And this dominant way of understanding outsider art, in turn, often results in a perspective that does not line up with outsider artists' intentions for their work, resulting in a false heroism and ironic interpretations of the work.

These divergent perspectives lead to some big questions about how we can ethically enjoy outsider art. One solution is to tone down the language about outsider art, to tone down claims about its authenticity, innocence, danger, and originality. Acknowledging the sometimes modest goals of these works and putting the mainstream art world's big claims to the side, we might profitably enjoy what this work does—it amazes us with its inventiveness, its psychological intensity, its proposing solutions to problems that we didn't even know existed. The resultant experience may still be conflicted, impure, or difficult—which brings us to the concerns of our next chapter.

ART and DIFFICULTY
Foucault's Nightmare

For many, the experience of walking through Ann Hamilton's large installation *the capacity of absorption,* at the Museum of Contemporary Art in Los Angeles from late 1988 to early 1989, was a puzzling experience. The walls of the first of the installation's three rooms were lined with beeswax-covered paper. Attached to the walls were 150 copper and glass sconces, each with a tiny swirling whirlpool. The swirling and its gentle sound would stop when one spoke into a microphone, which was located at the large end of what looked like a giant ear trumpet made of human hair. The room also contained a video screen that showed a human ear; as one watched the ear on the screen, the screen itself seemed to repeatedly fill with water. In the second room, the walls were covered with pond algae. There was a long table filled with running water in the center of the room. At one end of the table was a live attendant, whose hands were placed into holes in the table's surface. The attendant's coattails thinned into a large cord, which snaked into the third room, whose floor was covered with 10 tons of lead linotype and whose walls were rubbed with pencil graphite. There, the coattail was connected to a large rusted ocean buoy (Color Plate 13), which was etched with the lines and numbers of a nineteenth-century phrenology diagram (a "map" of the human skull).

Wandering through this bewildering excess, a perplexed viewer may well have asked the questions that many people continue to ask of twentieth-century Western art in general: Why is so much contemporary art difficult to understand? Is making art that is difficult to understand something that artists have intentionally done? Why does difficult art make me feel uncomfortable? Will work that is difficult to me right now always seem difficult? Is difficulty central to twentieth-century art, or is it a by-product? If I don't understand something, is it probably my fault? These questions, although perhaps naively stated, are central to understanding not just the properties of difficult art but, more fundamentally, the relationship of twentieth-century artistic expression to its audiences. Although

some of these issues also apply to the institution of the museum, to the art of other cultures, and to outsider art, we will take a new direction in this chapter. In the previous chapters, we examined how art is institutionalized through museums and the canon and how Western culture has understood the art of other cultures and the outsider within Western culture; in this chapter we will consider how Westerners understand the unfamiliar, difficult art *inside* mainstream art culture.

For the general public, questions about difficult art are often manifested in visceral responses. In December of 1910, for example, the art critic Roger Fry organized an exhibit of late-nineteenth- and early-twentieth-century artists; the London show was known as the "Post-Impressionist Exhibition." Featuring the art of Gauguin, Cézanne, and others, the show presented many works that were new to the general public and employed techniques unfamiliar to the general gallerygoers, such as the use of distortion and harsh, jarring colors as an expressive technique. The difficulty of this work produced various reactions. Some laughed at the work, whereas others angrily shook their umbrellas at it. The famous critic and secretary of the show, Desmond McCarthy, reported on "a stout elderly man of good appearance, led in by a young woman, who went into such convulsions of laughter on catching sight of Cézanne's portrait of his wife in the first little room that his companions had to take him out and walk him up and down in the fresh air."[1]

Although the audience that laughed at the **postimpressionist** show is one of the most famous examples of how people respond to difficult art, we are not limiting the use of the word *audience* in this chapter to an uninformed group with a predisposition to hate the products of high culture. Even someone as sophisticated as the critic Leo Steinberg has mentioned

> the shock of discomfort, or the bewilderment or the anger or the boredom which some people always feel, and all people sometimes feel, when confronted with an unfamiliar new style. When I was younger, I was taught that this discomfort was of no importance, firstly because only philistines were said to experience it (which is a lie), and secondly because it was believed to be of short duration.[2]

The viewer of Hamilton's installation, the audience at the postimpressionist show, and the critic Leo Steinberg all illustrate two things: many people have felt that the art of the twentieth century is difficult, and difficult works make them anxious, uncomfortable, and even angry. Some people think this is a terrible thing, yet others think this is precisely what art ought to do. In any case, almost everybody has strong opinions about difficult art; there are few middle-of-the-road reactions.

[1]Quoted in Ian Dunlop, *The Shock of the New: Seven Historic Exhibitions of Modern Art* (New York: American Heritage Press, 1972), 120.
[2]Leo Steinberg, *Other Criteria: Confrontations with Twentieth-Century Art* (Oxford: Oxford University Press, 1972), 5.

Difficulty Defined

Defining what makes art difficult is not a straightforward matter. A helpful starting point is to think carefully about what one means by the term *artwork:* an artwork is not just an object; it is an object (or event) that *does* something. The most basic thing an artwork does is give its viewers an implicit set of instructions for its use; it suggests ways in which it ought to be experienced.

For example, consider Rembrandt's *Self-portrait at the Easel* (Color Plate 14). Like many artworks, this painting has a frame that announces there is a boundary to this piece—the painting is separate from its surroundings, portable, complete in itself, and, perhaps, usable in the same way no matter how its surroundings may change. In many ways, this piece communicates that it is a finished work—no bare patches of canvas here; nicely framed, varnished, and titled; and bought and paid for. It is, therefore, not appropriate to think of this finished work as a process, as part of an event, as something that might be changed. Its relatively modest scale (111 by 90 centimeters) suggests the work is designed for a domestic space. The painting is rectangular and hangs on a wall, encouraging us to use it not as a table or as a carpet but as something only to be seen, not handled. And there are lots of things about its current museum context that underscore its intended use: we can't touch it; there are guards; there is nothing else in the room that would encourage activities other than just plain looking. So, *Self-portrait at the Easel* is not a utilitarian object in the way that a hide-a-bed, a toaster, or an exercise bike is.

The work has been given a title, which we are to use as an interpretive guide. The signature on the painting says that this work is an expression of an individual. Together, the artist's signature and the painting's title suggest that we are to see this piece not only as *a* Rembrandt but also as a depiction *of* Rembrandt. The work also tells a story (the artist is in the act of painting himself) that we are to recognize and react to. The artist is gazing into a mirror, and we, the viewers, are in the position of that mirror. We are being confronted by Rembrandt as he confronts himself. The fact that *Self-portrait at the Easel* is skillfully painted and that it took a long time to complete suggests that it should be treated carefully and with respect (a respect enhanced by its having survived, under the protection of a museum, for many years). All of these things (and undoubtedly others) indicate that the object is part of the tradition of Western painting, and therefore viewers can fit it into a context that is defined by a chronology, by national identities, by materials, by subject matter, and by a whole complex of social relations.

As viewers, we are typically unaware that we are following these implicit instructions; we usually do not consciously think about how the frame or the scale of a painting contributes to its meaning. However, these unarticulated, unconscious processes are totally necessary for us to see *Self-portrait at the Easel* as a work of art. Many artworks within an individual viewer's own culture function in this straightforward way: the basic levels of interpretation are done silently and are unrecognized. Because they are done silently, they also seem effortless, unproblematic. This is not to say that these instructions *must* remain

unarticulated. For example, if a work is startlingly large (for example, 30 feet wide by 10 feet high) with a spectacularly elaborate frame (perhaps an intricately carved 8-inch border made of ivory), we are nudged to think about such things as the frame and the scale and how they contribute to what the painting means. But the work may still not be difficult—because we are capable of carrying out these instructions unconsciously, and these unusual instructions in this case do not make interpretation difficult. The large scale may, for example, unproblematically tie the work to the tradition of **heroic painting,** such as David's 20-by-30½-foot work *The Coronation of Napoleon* (Figure 4.1). Such scale is more problematic, say, in the case of Claes Oldenburg's large vinyl hamburger (see Figure 3.6).

But with difficult work, the process of interpretation changes: that which usually goes unsaid (what in a "traditional" Western work of art is usually unproblematic and unarticulated) becomes suddenly a *central* concern (that is, it becomes both problematic and articulated). The difficult work sometimes unsettles its viewers by emphasizing ways of making meaning that are usually unarticulated, instinctual. For example, consider the case of color. We typically—perhaps always—notice color in paintings. But in *Homage to the Square: Apparition,* Joseph Albers reduces painting to only the elements of color and shape; these two elements become so dominant that we are required to consciously think about their relationship (Color Plate 15). The things we usually take for granted now become the central topic, and we are suddenly aware of how little we know about them, of how complicated these simple interrelationships really are. This disruption of our unconscious interpretive processes is heightened in work that seems strange to us, such as some of the art of other cultures or outsider art.

But in addition to drawing attention to that which is often instinctual, the difficult work (including the art of other cultures) can also present unclear, unfamiliar, or too difficult instructions. Sometimes a work does not clearly communicate what type of work it is or, more importantly, even that it *is* a work of art. When in 1936 Meret Oppenheim presented *Object* (a fur-lined teacup) as an art object, viewers were taken aback, not just because it was creepy but also because it was not obvious that this *was* an artwork (Figure 4.2). The uncertainty introduced by an object such as a fur-lined teacup (or, for that matter, an enormous vinyl hamburger or a table set for dinner or a pile of bricks or a Volkswagen bus pulling twenty sleds or a stainless steel bunny) is important to understanding difficulty, because the first and most basic task of interpreting an artwork is this: an object or event first asks us to recognize that it is indeed presenting itself as art. *Is it art?* is the big question: as soon as we feel the need to ask this question of an object or event that is presented to us as art (whether high art, outsider art, or art of other cultures), it's difficult art.

Further complicating matters is another question that viewers need to ask: On what basis is this thing presenting itself as an artwork? Duchamp's *Fountain,* a porcelain urinal displayed at the Philadelphia Museum of Art, clearly asks viewers to do something other than urinate in it. It asks them to consider it as a work of art, a step that leads to yet another question: *Why* should this be considered art? The answer is disarming and, to some, infuriating: this is a work of art

Figure 4.1 Jacques-Louis David, *The Coronation of Napoleon,* 1805–1807. Oil on canvas, 20 ft. × 30 ft. 6½ in. The Louvre. (© Photo RMN.)

Figure 4.2 Meret Oppenheim, *Object* (*Le Déjeuner in fourrure* [Luncheon in Fur]), 1936. Fur-covered cup, saucer and spoon: cup diameter 4⅜ in. (10.9 cm); saucer, diameter 9⅜ in. (23.7 cm); spoon, length 8 in. (20.2 cm). Overall height 2⅞ in. (7.3 cm). The Museum of Modern Art, New York. Purchase. (Photograph © 2000 The Museum of Modern Art, New York.)

because Duchamp *decided* that it was a work of art. So a common response to Duchamp's *Fountain* or Oppenheim's *Object* is, Is this thing a work of art? More precisely, people may ask, Is this thing doing what art is supposed to do? One could ask of Albers's *Homage to the Square: Apparition,* Why is the simple relationship of color and shape enough to qualify this as a work of art? But it's not just formal aspects that prompt this kind of questioning; subject matter, too, can make an artwork difficult, as in Duchamp's *Fountain,* Oppenheim's *Object,* and Robert Mapplethorpe's sadomasochistic portrait of himself with a bullwhip inserted in his rectum.

Is it art? is not, however, the only question that defines the difficult artwork. If someone decides an object or event is an artwork, the work's instructions (its size, technique, subject matter) necessarily call on the viewer to make some judgment about what it means. Sometimes we recognize a piece as an artwork but are unclear as to the type of instructions the artwork is giving. We implicitly ask, What do we need to *do* to understand this piece? When we look at Pollock's *Autumn Rhythm* (see Color Plate 3), where should we direct our attention? to the center? to the relationship between foreground and background? to the ground in front of the painting, where bits of the paint have fallen? A similar line of questioning applies to the art of other cultures: What do I need to do to understand a Dogon granary door (see Color Plate 8). Are its formal properties important? What of its original function do I need to understand?

Further, in what order should these questions be answered? Unlike in reading, in visual art there is no agreed upon order of interpretation. That is, in reading, levels of interpretation work something like this: a reader first decodes squiggles as letters, then understands how these letters make up words, and then makes decisions on how these words work together to make assertions about the world. But in visual art there is no agreement upon what one first sees; the only agreed upon thing is that what the viewer is looking at is indeed an artwork.

Sometimes a viewer may know what do, but the interpretive tasks of the artwork are just too difficult for that viewer to perform. This is often true of art that depends heavily upon a body of knowledge, a body of knowledge that may be unfamiliar to the viewer. For example, on the south portal of Chartres Cathedral, Saint Martin gives the beggar half a cloak (Figure 4.3). Why does he do that? Consider another example. During the 1980s, Sherrie Levine made watercolor copies of reproductions of artworks. For many, Levine's works were difficult on several levels. In addition to asking the question Is this art? the artwork required viewers to have a knowledge of art history. Further, one really needed to know that these were copies of *reproductions* and not of the originals, and one needed to be familiar with current critical art theory, which was interested in theories of originality, individualism, and repetition.

Both Chartres and Levine's work present knowledge-based problems: when the viewer is able to use the required knowledge effortlessly, the difficulty radically lessens—or just gives the work a nice tangy flavor. But, for most people, Levine's work, based on French theorist Jean Baudrillard's theory of the **simulacrum** is just difficult, because they have to consciously call up everything they know (or think they have heard) about Baudrillard's thinking. When viewers do

Figure 4.3 Figure of St. Martin (lower left), 1205–1235. Chartres Cathedral, South Portal, France. (Peter Willi, © Bridgeman Art Library.)

not think they ought to be required to have the knowledge to interpret a given artwork, they call it difficult—and sometimes illegitimately difficult. They get upset, suspecting the work is elitist.

Difficulty, then, arises from a relationship between art and the viewer. This relationship has several important consequences: an artwork has no meaning outside of a relationship with the viewer, and it implicitly asks the viewer to use the artwork in certain ways. Difficulty, like art itself, arises from the peculiar social conditions that surround a work of art. Further, a work's difficulty is subjectively determined; it is a mix between a work's implied instructions for use and a viewer's personal abilities. In an important way, difficulty is more a behavior than it is a property. No artwork is inherently difficult, just as any work of art has the potential to be difficult.

Values of Difficulty

Difficulty is not a permanent, unchangeable feature of a work of art. As mentioned, difficulty arises from a relationship between the viewer and a work, and, like all relationships, it is subject to change: difficulty may increase, decrease, or undergo a complete character change. According to many in the art world, this change is essential to the process of understanding a difficult work, and they argue that difficulty often decreases when a new work has been around for a while. In fact, some claim that this change is the norm, that difficulty *always* disappears as a work becomes accepted. The critic Leo Steinberg certainly holds this view. After grumbling about what he had been taught about difficulty, he goes on to assert that "no art seems to remain uncomfortable for very long. At any rate, no style of these last hundred years has long retained its early look of unacceptability."[3]

Why does difficulty disappear? It can disappear because the instructions the difficult work seems to be presenting gradually become clearer and make the work less difficult. The context to which the new and difficult work belongs gradually becomes clearer. And as this context clarifies, viewers create a tradition to which the artwork belongs. Jackson Pollock's work, for example, which at first was seen as totally new and outrageous, is now seen in the context of earlier cubism, surrealism, and the tradition of heroic painting. But this tradition can also point forward. Many in the art world no longer see Barbara Kruger's work as very difficult because postmodernism has broken down the barriers between high art and advertising (Figure 4.4). Many viewers are no longer shocked by works that look like advertisements; they are able to use the instructions of advertising in the context of high art with some ease.

But what if the context of an artwork is not immediately available to the viewer? Sometimes the solution is education. Through education, difficulty can be dissipated. If one acquired the necessary knowledge, the difficulty would resolve

[3]Steinberg, *Other Criteria*, 5.

Figure 4.4 Barbara Kruger, *We don't need another hero*, 1986. A billboard project commissioned by Artangel, London.

itself. Difficulty, then, when it is knowledge-based, is something to be removed. In this view, difficulty is a negative thing that needs to be addressed if one is to authentically experience an artwork. This is partly why museums all have education departments and trained docents who give educational tours to busloads of museumgoers of all ages.

But difficulty is not just something that has to be removed, scraped away like the moldy end of cheese in order to get at what is edible. Difficulty also has enormous value in twentieth-century art. Some claim that difficulty is not only valuable, it is *inherent* to good art; it is a permanent, essential quality that all great works of art have. The critic Jeremy Gilbert-Rolfe, in his discussion of difficult art, claims that art's "secret resides in its ultimate unexpressibility in any other form than its own, its final untranslatability, its resistance to interpretation. Therein lies its difficulty, its irreducible seriousness."[4] Even an earlier formalist critic such as Clement Greenberg believed that difficulty was essential to great art and that art that was not difficult was merely **kitsch**.

How can these two ways of thinking about difficulty—that it should be removed and that it has a positive value that cannot be removed—exist side by side? Part of the answer is that these are two different types of difficulty: the difficulty that should be removed is always described in knowledge-based terms; the difficulty that is valuable is not described in these terms. Thus, when looking at Chartres Cathedral, it is better for the viewer to know why St. Martin gives the **beggar** half a cloak. On the other hand, Donald Judd's stacked minimalist boxes would lose a lot of their aesthetic clout if the difficulty of understanding them were radically lessened (Figure 4.5). They would become mere decoration. But perhaps the tension between these two types of difficulty cannot be completely resolved. This tension is probably felt most urgently by people who both wish to maintain art's enigma but who also believe that art is engaged in a more social act, one that should benefit all people.

Those in the twentieth century who value difficulty and think that it should not be removed, describe the value of difficulty in a curious way. For most, difficult work is to be valued not because it provides pleasure but because it is important. The difficult work is more often a grim work than a happy work—Gilbert-Rolfe's use of the word *seriousness* is no accident. And this seriousness is an intellectual rather than a sensual activity—the sensual aspects of a difficult work are important primarily as they contribute to intellectual recognition. There are four major ways in which people defend difficulty as seriously important. The first and most widespread argument is that the difficult work is unsettling and revolutionary. The remaining three defenses, which are significantly less widespread than the first, are that difficult art reveals something about the conditions of art, that it mirrors the difficulty of culture, and that it mirrors the difficulty of the human mind. These ways of defending difficulty are not always

[4]Jeremy Gilbert-Rolfe, "Seriousness and Difficulty in Contemporary Art and Criticism," in *Theories of Contemporary Art,* ed. Richard Hertz (Englewood Cliffs, NJ: Prentice-Hall, 1993), 148.

Figure 4.5 Donald Judd, *Untitled*, 1965, galvanized iron, seven boxes, each 9 in. × 40 in. × 31 in. (22.9 cm × 101.6 cm × 78.7 cm), 9 in. (22.9 cm) between each box. Hirshhorn Museum and Sculpture Garden, Smithsonian Institution, gift of Joseph H. Hirshhorn, 1972. (Photo by Lee Stalsworth. © Donald Judd Estate/Licensed by VAGA, New York, NY.)

distinct from each other; certain works display more than one of these forms of difficulty.

Difficult Art as Unsettling and Revolutionary

First, let's consider the most widespread belief about difficulty's serious importance: the belief that the difficult work is unsettling and revolutionary. According to many in the art world, difficult art can be important because it compels us to change our lives, both aesthetically and politically. Difficulty makes us nervous and uncomfortable in a way that is conducive to social or aesthetic change—in this way it is unlike work that isn't difficult, work that just affirms what we know. This unsettling push to change is an important function for twentieth-century art. As critic Suzi Gablik claims:

> Difficult and disturbing art acts as a countertendency to this leveling process [what Gablik terms the "monotonous routines" of modern life]— precisely because it disrupts our habits of thought and strains our understanding. By being subversive of perception and understanding, art can break through stereotyped social reality and produce a counter-consciousness that is a negation of the conformist mind. Indeed, it is only through *estrangement*—according to Herbert Marcuse—that art fulfills its function in modern society. Its "negating power" breaks the false automatism of the mechanical mode of life.[5]

In other words, difficult art, by unsettling its viewers' relationship with the artwork, also tends to unsettle their habitual interactions with the dulling aspects of contemporary life. This assertion that difficulty is necessary to good art may be one reason why to the art world the most valuable art is seen as unsettling, edgy, and not "pretty."

In visual art, unsettling difficulty that pushes for change does not just arise from problems with basic comprehension; it can also arise in a work's involvement with moral issues. For example, Robert Mapplethorpe's work is seen as difficult, as is Nan Goldin's *The Ballad of Sexual Dependency*; both artists document a startling range of sexual behaviors. That these artists' work is often called difficult may seem counterintuitive, for both artists' work is in many ways straightforward, neither aesthetically nor intellectually difficult. As a result, to many viewers who feel uncomfortable in the presence of their work, it isn't difficult, it is pornographic or just "dirty." The viewer's insistence on a work's obscenity (and not its difficulty) has powerful consequences. When one claims that Mapplethorpe's work is not difficult but that it's just pornographic, one refuses to tie it to any of the traditions of high art; one refuses to consider that it might be art.

Yet, on an important level, work such as Goldin's *The Ballad of Sexual Dependency* is difficult in the same way as difficult intellectual art, such as Sherrie

[5]Suzi Gablik, *Has Modernism Failed?* (New York: Thames and Hudson, 1984), 37.

Levine's copies of reproductions. In both artists' work, viewers are uncertain as to how to proceed in a safe and effective manner; the instructions seem risky, with an uncertain end in mind. For both artists' work one can reasonably ask, How can I look at this and still hold on to what I believe? (This is what people mean when they say a work challenges their beliefs.) Further, the first question is, Is this art? Both Goldin and Levine violate basic notions of what it means to produce art. One violates intellectual codes of originality; the other violates moral codes of propriety. By raising these questions, both artists' work attempts to change our usual categories of what counts as art.

Moreover, the differing ways in which Goldin and Levine address the question Is this art? aren't as separate as they might first seem. Goldin's representations of the taboo, because they challenge gender constructions or definitions of obscenity, are intellectual challenges. And in both her and Levine's works, choices about what is appropriate, allowable, or legitimate to represent are also aesthetic issues. Further, for some viewers Levine's work too may seem morally outrageous, a lazy stealing of property. But it is not only some kinds of art that have a moral dimension. Every artwork has a social function and a use; every artwork has a moral dimension—though we less easily recognize this in work with which we readily agree.

It is important to note that the kind of morally charged difficult work we have been discussing invariably elicits a strong response from its viewers. Thus even though they "understand" a given work, viewers are challenged by it. And they don't always want to change. For example, consider a racially charged body of work, such as that of African American artist Carrie Mae Weems. In her 1987 series *Ain't Jokin'*, Weems created two-part works in which the first part was the question of a racist joke and the second was the answer. In some of these pieces, one even had to approach the work closely and lift a small panel to read the punchline. Sometimes critics speak of such work as "implicating" its audience. When we as viewers feel implicated by a work, a curious thing happens. We feel as if the work is assuming we usually use the ideas presented in it in a certain way. Moreover, this implied use is something we feel resistance to admitting. In the presence of the artwork, we don't want to laugh at the racist joke. In the case of Weems's work, we understand the instructions the text may be giving, but we don't want to engage in imaginative empathy with it. We do not want to perform its instructions.

Consider another example. In the spring of 1997 the Museum of Contemporary Art in Chicago exhibited *Santa's Theater* (Figure 4.6), an installation of the Los Angeles artist Paul McCarthy. At the center of the installation stood a small hut with a guard at the door. In order to enter the hut, one had to choose one of three possible costumes: an elf, a reindeer, or a Santa. People smiled and joked as they put on their cute costumes but looked slightly puzzled at the sign that prohibited entry of minors into the hut. The museum guard restricted entry to twenty people at a time. The hut was dark inside, but gradually one made out two rows of seating along either wall. Upon finding a seat, viewers had two choices of where to look: either at the row of slightly embarrassed people sitting opposite them or at one of the two video monitors at the narrow ends of the

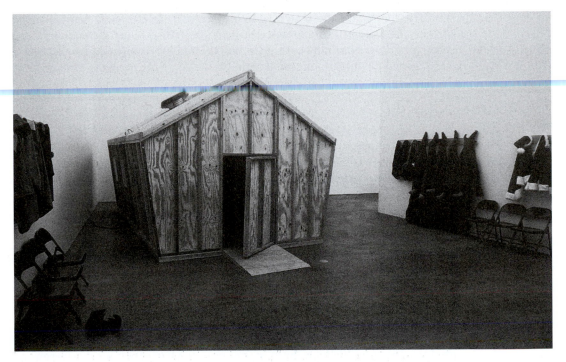

Figure 4.6 Paul McCarthy, *Santa's Theater,* 1997. Installation view, "Performance Anxiety," at the Museum of Contemporary Art, Chicago. (Photo courtesy the artist and Luhring Augustine, New York.)

room. The figures on the screen were also dressed in elf, Santa, and reindeer costumes and were in a similar wooden structure. That's when the horror kicked in: the figures were partially covered in blood and bodily fluids and were strenuously engaged in ambiguous sexual activity. Suddenly the cuteness vanished in a palpable sense of communal discomfort among the silent viewers. This uncomfortable response, a classic example of complicity, was partly achieved by McCarthy's having his audience wear exactly the same costumes as the actors and sitting in the same kind of structure. He may not have been able to predict, however, the response of one of the viewers (although he would have approved). This viewer, a middle-aged man, spontaneously broke the silence with a small voice: "I feel icky. I need to find an adult I can trust and tell him."

In its most extreme form, such art makes the viewer an accomplice in violating some taboo, and the viewers experience a strong emotional response, such as anger, anxiety, thrill, or guilt. Such artworks do not merely present beliefs to be "tried on"; they immerse their viewers in the consequences of a belief, engage them in participation through the act of viewing. Viewers are made to feel complicit in the violation or to feel violated themselves.

Note: There is a difference here between those who readily examine such a work and those who refuse to consider it. People who imaginatively empathize with the strategies of this complicit art (and that is not the same as believing that one is racist or perverse) more readily call it difficult than those who don't. Those who don't are more likely to think of Weems's or McCarthy's work as irritating rather than difficult.

For people who assign this kind of unsettling, revolutionary function to difficult art, difficulty becomes a moral issue of a peculiar kind: the serious viewer works hard at understanding art; conversely, an unwillingness to struggle with difficulty is a sign of laziness. There is often a macho edge to all of this, an over-the-top rhetoric that is reminiscent of the rhetoric of outsider art and primitivism. Harold Rosenberg, during the course of an argument that equates newness with a "valuable" form of difficulty, makes the following point: "A full grasp of the new is accompanied by a species of terror, of the sort not unknown to research scientists, explorers, mystics, revolutionists."[6] Even more strenuous is the exhortation of critic Constance Perin: "Only if artists, humanists, and scientists strike out in search of the new, unusual, and difficult can they bring the work of the world to higher ground. They must act without fear, yet they leave others trembling. We call their fearlessness creativity. Our own, for receiving their message, needs no less cultivation and courage."[7]

[6]Harold Rosenberg, *The Anxious Object: Art Today and Its Audience* (New York: Horizon, 1964), 233.

[7]Constance Perin, "The Reception of New, Unusual, and Difficult Art," in *The Artist Outsider: Creativity and the Boundaries of Culture*, eds. Michael D. Hall and Eugene W. Metcalf (Washington: Smithsonian, 1994), 195.

Difficult Art as Revealing the Conditions of Art

In addition to seeing the difficult work as unsettling and revolutionary, people have also claimed that difficult work can be important because it makes a statement about the status and conditions of art. People refer to this kind of difficulty when they speak of a work as a "painting about painting" or when they talk about "the nature of representation." One of the things Jasper Johns's 1960s flag paintings do is raise the question, When is an image of a flag a flag, and when is it a painting? (Figure 4.7). Duchamp's urinal was considered to be a difficult work of art because it raised questions about the qualities that make an object *art* (the Is it art? question). This, of course, is what many people have argued modernism was all about—from Duchamp's urinal, to Oppenheim's teacup, to Picasso's collages, to Johns's American flags. In this view, work that is "too easy" is work in which a given art's procedures for making meaning aren't emphasized. Sometimes this defense overlaps with the idea of difficulty as being revolutionary. Sherrie Levine's "reproductions," in addition to being defended as unsettling, are difficult also because they reveal the conditions of art.

Difficult Art as Mirroring Culture and the Human Mind

The third and fourth ways of valuing difficulty—as mirroring the difficulty of culture and as mirroring the difficulty of the human mind—are both ways of thinking about art as **mimetic,** that is, the belief that art reflects an aspect of reality. The two aspects of reality that dominate discussions of mimesis are the artist's culture and the human mind. First, the difficult work can be important because in its difficulty it reflects the true difficulty of society. Harold Rosenberg claimed in 1964: "Today, extremist forms in art are everywhere accepted as a reflex to incomprehensibles in science and technology and to the bafflement of philosophy."[8] Art is difficult because contemporary culture is difficult. If art were not difficult, it would be less true to its times.

But a difficult artwork can also be important because it is psychologically mimetic, because it reflects the actual complexity of the human mind and the creative process. Commentary on Jackson Pollock's line of abstract expressionism works in this tradition. Pollock's work is a record of the process, a record of his psychological state. According to art historian Stephen Polcari, Pollock in his drip paintings of the late 1940s and early 1950s attempted a "linear automatism," which was "intended to record the spontaneous impulses, the unforeseen and antirational vitality of the subconscious, in lines and marks from which the artist picks up cues to make a painting or drawing."[9] Pollock himself claimed that "the modern artist . . . is working and expressing an inner world—in other

[8]Rosenberg, *Anxious Object,* 210.
[9]Stephen Polcari, *Abstract Expressionism and the Modern Experience* (Cambridge: Cambridge University Press, 1991), 256.

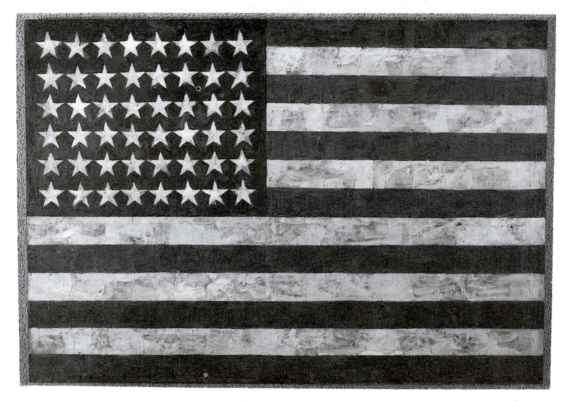

Figure 4.7 Jasper Johns, *Flag,* 1954–1955. Encaustic, oil and collage on fabric over plywood, 42¼ in. × 60⅝ in. The Museum of Modern Art, New York. Gift of Philip Johnson in honor of Alfred H. Barr, Jr. (Photograph © 2000 The Museum of Modern Art, New York. © Jasper Johns/Licensed by VAGA, New York, NY.)

words—expressing the energy, the motion, and other inner forces."[10] Because of the radical psychological subjectivity of this kind of work, such art is inevitably difficult.

Because difficulty gives rise to valuable aspects of artistic expression (the four defenses we have just discussed), it has an important role in deciding the value of an artwork. On the one hand, there is pressure to increase the cultural value of an inherently simple work by highlighting those aspects of the work that can make it more difficult (its unclear, too difficult, unfamiliar, or unarticulated instructions). For some, David Hockney's paintings are more than just a banal celebration of suburban life, and Mary Cassatt's work is more than an unadventurous late-nineteenth-century portrayal of motherhood. The point is this: in the twentieth century, if one could ratchet up the difficulty of a given work, typically the work was perceived as having more cultural value. (Indeed, difficulty can even have a commercial value. This is not to say that difficult art is the only art that has commercial value. But difficult art has a particular kind of commercial value: difficulty is a sign of serious art, the art that serious collectors want to collect.)

But there is a flip side to difficulty's role in determining the value of an artwork. Given the sorts of value that difficulty has in modern aesthetic experience, if a work's difficulty disappears, it has a reduced aesthetic value. Recall the discussion in Chapter 1 of Auguste Renoir's fading reputation. Renoir's work has taken on the status the literary theorist Hans Robert Jauss has called "culinary art"—art that is tasty, easily consumed, and perhaps a bit too satisfying. Walter Robinson, cheerfully joining in the Renoir roast in *Art in America,* quipped: "His sunny scenes are prophetic of the modern postcard, his sensibility is common ancestor to Norman Rockwell, Barbie and slice-of-life advertising."[11] Although Renoir is still in the canon, he is no longer taken as seriously as he once was because he is no longer seen as difficult. In a way, art historians don't see him anymore—just as people don't see the work that presents no difficulties; it fades into a warmish rectangular spot above the couch. Keith Haring's ubiquitous graffiti art is perhaps the latest version of this fading importance (and his co-optation by Madison Avenue and Sesame Street may not be Haring's fault).

Many critics believe that although difficulty is often extremely important in assessing a work's value, difficulty is not an *inherent* aesthetic value. It is not the case that if difficulty is valuable, the most difficult works are also the most valuable. Work that is too difficult is unreadable and unusable. For a difficult artwork to have a positive aesthetic function, it must have the right balance between difficulty and ease. As viewers, we attempt to bring difficulty within acceptable limits. Work that is too difficult is either boring, confusing, or terrifying. People are meaning-making beings, and we get anxious when we encounter something that seems as if it ought to have some kind of expressive meaning but

[10]Quoted in Polcari, *Abstract Expressionism,* 255.
[11]"Renoir: A Symposium," *Art in America* 74 (March 1986): 120.

we cannot find it. Work that is too difficult frequently produces reactions similar to those caused by embarrassment or irritation: laughter, rage, anxiety.

When we encounter an artwork that is too difficult, we cross a boundary of sorts, for too much of the meaning-making becomes laborious and conscious, or even impossible, and our confidence in our abilities is diminished. Art becomes something to be avoided. This boundary is personally determined and subjective. The personal dimension of the difficult experience gives difficulty a really awkward place in the discussion of art. Admitting that something is "too difficult" can be embarrassing or irritating—especially when "struggling" with difficulty is portrayed as a "heroic" endeavor.

This search for balance between difficulty and ease suggests that difficulty is not an inherent value of "good art"; it is not true that the more difficult a work is, the better it is. We are not claiming that just because something is difficult it is necessarily good. Difficulty makes it hard to make aesthetic judgments, because difficulty is always the thing that must be first addressed and answered in some way. Valuing difficulty also raises the problem of elitism. A belief in difficulty's inherent value can also too easily assume that the only integral relationship between an artwork and its public is an antagonistic, uncomfortable one. People who value difficulty too easily assign nondifficult work to the category of the "merely" decorative. For example, in the 1970s the **pattern and decoration movement** was reacting against the fact that modernism had consigned the idea of the decorative to the status of nonart (Figure 4.8). These artists intentionally made decorative works, which ironically became difficult in that context: the first question viewers asked when confronting these decorative works was also the first question that was asked of Duchamp's artwork—Is this an artwork? How could the decorative—or, more specifically, painting that looks like wallpaper—have the status of art?

Visceral Difficulty

Difficulty is not a neutral aesthetic effect; people react to difficult work in very physical ways. Being unable to understand makes people do weird things. The French postmodern theorist Michel Foucault, in an unsettling moment of self-revelation during an interview, claimed: "Personally I am rather haunted by the existence of discourse." A few moments later he related the following anecdote:

> A nightmare has pursued me since childhood: I have under my eyes a text that I can't read, or of which only a tiny part can be deciphered; I pretend to read it, but I know that I'm inventing; then the text suddenly blurs completely, I can no longer read anything or even invent, my throat constricts and I wake up.[12]

[12]Michel Foucault, *Foucault Live*, ed. Sylvère Lotringer, trans. John Johnston (New York: Semiotext(e), 1989), 25.

Figure 4.8 Kim MacConnel, *Furnishings*, 1977. Installation at Holly Solomon Gallery, New York. (Courtesy the artist and Holly Solomon Gallery.)

Although Foucault is one of the most influential cultural theorists of this century, it is not his theoretical stance that is striking about this passage; it is his physical state, Foucault's personal response to not being able to understand: his determinedly pretending to read even when he knows he is inventing, the tightening of his throat, and his escape from the problem into consciousness. Foucault's inability to understand the text made him physically anxious, trapped: that is the classic reaction to difficulty.

The difficult work provokes a peculiarly visceral reaction of anxiety, of being unsettled. The responses to difficult art often play themselves out in curiously predictable ways. For those who find a work too difficult, anxiety and then rage or laughter are the dominant responses. In 1913, the twenty-sixth president of the United States, Theodore Roosevelt, visited the Armory Show in New York City. The show exhibited current work in American and European art, and it was the first time most of the audience had seen such artists as Picasso, Cézanne, Matisse. For a majority of the viewers, this art was very difficult, unlike anything they had ever seen. According to one report, an angry Roosevelt "waved his arms and stomped through the Galleries pointing at pictures and saying 'That's not art!' 'That's not art!'"[13] Roosevelt was not alone. When the show visited Chicago, students from the Art Institute rallied and dragged through the streets an effigy of Henri Matisse (renamed Henri Hairmatress), which was then "accused and convicted of a long list of crimes, then stabbed, pummeled, and dragged about the terrace [of the art museum] to the edification of a large crowd on Michigan Avenue."[14] Editorial cartoonists licked their lips and set to work, churning out cartoon after cartoon of Duchamp's *Nude Descending a Staircase,* which was the scandal of the exhibition.

The reaction to the Armory Show is not that different from the public response to the National Gallery of Canada's decision in 1990 to purchase Barnett Newman's 1967 *Voice of Fire,* a large canvas (5.4 meters high by 4.2 meters wide) consisting of two vertical blue stripes on either side of a central red stripe. After announcing to the press the purchase price of 1.5 million U.S. dollars, politicians, editorial cartoonists, and many members of the public—not knowing (or thinking irrelevant) the history of abstract expressionism and the place of Barnett Newman in it—erupted. The question Is this art? was at the center of the furor. One member of the House of Parliament commented about Newman's painting that "it looks like two cans of paint and two rollers and about ten minutes would do the trick."[15] A cartoon in the Toronto *Globe and Mail* showed a woman complaining to a man who had just hung the painting: "What are you,

[13]Munson-Williams-Proctor Institute, Henry Street Settlement, and Association of American Painters and Sculptors, *1913 Armory Show. 50th Anniversary Exhibition 1963* (New York: Henry Street Settlement, 1963), 94.
[14]Milton W. Brown, *The Story of the Armory Show* (New York: Joseph H. Hirshorn Foundation, 1963), 178–79.
[15]Bruce Barber, Serge Guilbaut, and John O'Brien, eds., *Voices of Fire: Art, Rage, Power, and the State* (Toronto: University of Toronto Press, 1996), 29.

blind? You hung it upside down!"[16] A house painter near Ottawa painted a copy of the Newman piece, entitled it *Voice of the Taxpayer,* and offered it for sale at $400 (the cost of his supplies, plus his usual hourly rate).[17] Behind the ridicule there was, of course, real anger, and many insisted that the National Gallery had exceeded its mandate and that its directors should be fired.

But why should the reaction to difficult work be so emotional? Here we want to make a really strong point: *The reaction to difficulty is inherently and universally a visceral, emotional reaction.* First, once it is decided that a given object is an artwork (or a book, or a piece of music, or any other work of art), we human beings have an instinctive and restless drive to make it intelligible, to make it mean. In the difficult work, our desires are thwarted, and that thwarting is often very near the *beginning* of our experience of a work. Further, the nature of these desires to create meaning exacerbates the problems, for these are desires that are unused to being thwarted. That is, seeing is supposed to be nonproblematic, and when it isn't, it is as unsettling as losing our balance. We feel anxiety and powerlessness, and we react in an instinctual way with anger or its close relative, laughter—ways perhaps of expressing panic and of reasserting control over the difficult work, which has made us stumble. As Constance Perin points out, such reactions are a way of "keeping ambiguity and its uncertainties at bay."[18]

The visceral response to difficulty is a universal reaction because it is physiological, and this physiological response shapes the reaction to difficulty in the same way that it shapes people's responses to being lost in a strange city or entering a room and having everybody smile at them in an odd way. These are instances of being uncertain as to how to proceed, and that uncertainty produces anxiety. Granted, what gives rise to this response to difficulty may be culturally determined—not every culture may think the same things are difficult. But when people find things to be difficult, they react in similar ways. Of course, the response to difficult art shows that there are degrees of this physiological response, ranging from nervous smiles to elaborate cartoon ridicule, from mild irritation to violence.

Living with Difficulty

What are some of the strategies we can use with work we find difficult? Particularly, how can we address difficulty's subjective nature, a subjectivity that always results in one group that understands a difficult work and another group that doesn't? As a result of this subjectivity, for both the proponents and detractors of difficult work, elitism is always there, lurking in the foreground. For detractors of difficult art, the argument usually goes something like this: Art is supposed to be accessible to a public; difficult works have a small, privileged audience.

[16]Barber et al., *Voices,* 45.
[17]Thierry De Duve, "Vox Ignis, Vox Populi," in Barber et al., *Voices,* 81–95.
[18]Perin, "Reception," 178.

Therefore, the art is elitist, and because it does not reach a wide audience, it is of limited worth. Certainly, the Canada Council for the Arts or the National Endowment for the Arts shouldn't pay for it.

For proponents of difficult art, the argument goes slightly differently. Suzi Gablik cites the sculptor David Smith as arguing that "nobody understands art but the artist, because nobody is as interested in art, its pursuits, its making, as the artist." Gablik goes on to note that "from the start, the mystique of modern art has always been that it is not generally popular, or even comprehended, except by an elite few."[19] Notice that the elite that Gablik describes is not an elite of money and social class; it is an elite that *comprehends* art. The elitism of twentieth-century art has always been characterized primarily in these terms, using a model of the artist as professional and the central problem as one of comprehension rather than of pleasure. Smith argues that nobody *understands* art, not that nobody *enjoys* art.

Defenders of elitism make some standard claims. They argue that quality art has always been recognized by a small audience and never initially by a large audience. Van Gogh, Mondrian, Kahlo—take your pick and plug them into the story. Proponents of elitism assert that a small audience is necessary for the development of art because of this audience's commitment and intensity. And they claim that only a few people are going to be able to understand advanced ideas anyway. To have an elite is natural, and those who are not in the elite will catch up later.

Elitism is a complicated issue. Distinguishing between types of elitism doesn't necessarily solve the problem of elitist difficult art. It is not clear that an elitism based on intellectual ability is less suspect than an elitism based on money or class. A more useful distinction may be the following: some of the differing ideas about elitism arise because the different arguments are directed toward different *types* of art. Certain works and types of difficulty have a more uneasy relationship with elitism than do others. For example, it is less defensible to be elitist about art that is designed for public spaces than it is about art that is designed for a limited, professional audience.

Further, it is important to realize that everybody finds *some* work difficult; knowing this can help, because it shows we aren't alone, and that realization can reduce anxiety. Moreover, difficulty is highly subjective; just because critics do not think a work is difficult does not mean it shouldn't be difficult for everyone else. Although some critics might have found Ann Hamilton's installation *the capacity of absorption* a bracing but pleasurable artwork, the work was almost inevitably difficult for someone unfamiliar with installation art.

Additionally, the difficulty of an individual work can be changed in a number of ways. Viewers can reframe, or reconceptualize, a work so that some new instructions come with it or previously minor instructions become much more important. Cultural theorist Wendy Steiner describes such a reframing, which

[19]Gablik, *Has Modernism Failed?*, 12.

occurred at the Cincinnati obscenity trial involving the photography of Robert Mapplethorpe:

> Over and over, the jurors heard that "Art is not always pleasing to our eyes. Art is to tell us something about ourselves and to make us look inside ourselves and to look at the world around us." Or else they were told to judge the quality of the works by "look[ing] at them as abstract, which they are, essentially." All these characterizations ignore the naughtiness, the wicked humor, the irony, the titillating contradictoriness, the perversity of these works of art.[20]

The defense attempted to redirect how people looked at this work, either by talking about bigger, vaguer things or by zooming in to look closely at the work's formal qualities. But such reframing can evade the central difficulty of the work—in this case, its fetishistic homoerotic images, which are made all the more shocking because of their high degree of formal polish. Such reframing is remarkably similar to the way in which the West has often understood tribal art: either as formally pleasing objects or as examples of primitivism.

Another, more reliable way of changing the level of a work's difficulty is to consider on what basis this work is presenting itself as art: If this is something that could be called art, what kind of art is it? In attempting to answer this question, one either considers the work's social function or ties the work to a tradition, to a set of conventions.

An example of tying difficult work to a tradition can be seen in the critics' reaction to the 1913 Armory Show. In a letter to the editor of the New York *Evening Post,* Joel Spingarn, professor of philosophy at Columbia University, tied the Armory Show artists to the tradition of self-expression in art: "Wrongheaded, mistaken, capricious, they may all turn out to be for all I care; but at least they have the *sine qua non* of art, the courage to express themselves without equivocating with their souls."[21] Walter Pach, in a piece written in a publicity anthology entitled *For and Against,* while arguing that the work of the Armory Show cubists was "a radical departure from preceding forms," claimed that it yet created a tradition for these artists. The tradition for Pach was found in another art, in music:

> The men badly named "Cubists," have followed an exactly similar direction to that which was found in the art of music, and as, in the latter art, the possibilities of expression, were infinitely increased with the change from the representation of the actual to the use of the abstract, I think that the men conferring a similar increase in freedom in the graphic arts, would be entitled to our profoundest gratitude.[22]

[20]Wendy Steiner, *The Scandal of Pleasure* (Chicago: University of Chicago Press, 1995), 56.
[21]Quoted in Brown, *Story,* 156.
[22]Quoted in Munson-Williams-Proctor et al., *Armory Show,* 164.

What does this tying to a tradition and conventions look like in practice for a work such as Ann Hamilton's *the capacity of absorption?* First, one needs to recognize that this work was in the tradition of installation art. It was essential that viewers participate in the space of the piece. Viewers actively moved through the work. The work was not site specific (in that it could occur only in one gallery), but it was site sensitive (the particularities of the gallery at the Museum of Contemporary Art in Los Angeles had a big effect on the work: the walls and floor were part of the piece). There was a kind of psychological language in *the capacity of absorption* that had its roots in surrealism. The combination of charged images and the work's unusual materials, put together in a strange narrative, had its antecedents in 1930s surrealism. In addition, the work was in the tradition of excess, reveling in its medium like Jackson Pollock's *Autumn Rhythm* (see Color Plate 3). In Hamilton's work, the excess was found in the several tons of linotype on the floor, the 150 whirling sconces, the walls covered with seaweed. Finally, like many Western artworks, *the capacity of absorption* was interested in theories of communication, of signs: the giant ear trumpet, the phrenological buoy, and the interaction between the sconces and the human voice.

But tying difficult work to various traditions is not the only way to come to terms with its difficulty. Another way is to consider the difficult work's social function. What was the work's original purpose? What was it meant to do? Over the history of art, artists have been thought of as skilled workers, intellectuals, entrepreneurs, social critics, or social healers. (And sometimes they are a combination of two or more of these social roles.) Difficulty has often been a part of the work of artists who present themselves as intellectuals. Social healers, when they adopt the role of shamans, can sometimes present work that is difficult in an esoteric sense, presenting, for example, things that can be known only to the initiated.

Where did Hamilton's work fit? On the basis of what social role did it present itself as art? Clearly, in its address to theories of communication, it fulfilled an intellectual social role. Hamilton had a particular angle on communication issues. She made these intellectual issues embodied, sensual. Because her work was less about revealing idiosyncratic private secrets than it was about public communication, the issues she addressed had a large social dimension. She took on the role of social critic.

Finally, it may be important to consider whether a work's difficulty is *meant* to be resolved. And if the difficulty is not meant to be resolved, in a strange way, the anxiety drops. We don't need to be anxious about it; it's not our fault—in fact, we can investigate the pleasures of the difficulty. Then we can consider what the aesthetic payoff is for that difficulty.

Consider, for example, the work of Sigmar Polke. In the catalogue to the 1990 San Francisco Museum of Modern Art show of Polke's work, the critic Peter Schjeldahl writes: "But anyone who thinks that simple familiarity with Polke's output will dispel its obscurity has another think coming. To learn more and more about him, it has sometimes seemed to me, is to know less and less. His art is like Lewis Carroll's Wonderland rabbit hole, entrance to a realm of

spiraling perplexities."[23] According to Schjeldahl, this unresolvable difficulty is part of the essential value of this work, creating a visceral response that he describes as "a certain ache, like an ache to laugh, that is without issue, a sensation of blockage in the mechanism of humor, a monkey wrench lodged in the autonomic cycle of tension and release. It is a brief, fitful, not terribly pleasant feeling, but it is at the basis of my conviction about Polke."[24]

Polke's *Der Ritter (Knight)* illustrates the issues that Schjeldahl discusses (Color Plate 16). Although the work uses many of the conventions of painting (rectangular shape, descriptive title, stretched fabric), it strenuously resists interpretation. The work has different sign systems that float free of each other; none of the work's systems of representation make sense together: The title suggests some kind of recognizably represented figure, and there is a figure, but the resolution of it is degraded, and inconsistently so. A puddle of resin has been clumsily poured into a three-dimensional blob, while other parts of the painting are flat and precise, perhaps mechanically produced. The differing scales of the dot patterns are disorienting, as is the off-register printing. The overall pattern is interrupted with a white, stylized splatter. In this work nothing stays in focus, nothing seems to offer a starting point of interpretation. If this work is to have aesthetic value, it will not be the value of resolving difficulties but of playing difficulties off each other, enjoying the dissonances. Those who are most able to articulate these conflicting difficulties have the most chance of finding this work pleasurable.

Polke differs from Hamilton in that Hamilton offered interpretive ways into her work. Hamilton's installation presented two major sets of connected images: the whirlpools had connection to the seaweed, to the buoy, and to the table of water; the ear trumpet had connection to the video, to the voice-activated whirlpools, to the lead type on the floor, and to the phrenological diagram on the buoy. The big issues in Hamilton's work were much easier to reach than are the ones in Polke's painting—in fact, the ones in Polke's work are hard to identify. But in both cases, difficulty is an inherent part of the aesthetic experience, and knowing how to articulate this difficulty is a way of entering twentieth-century visual art and, to some degree, the art of other cultures and other times.

Conclusion

The discomfort people feel in the face of difficult art is central to understanding much twentieth-century art. This discomfort sometimes extends to the very status of the artwork itself: difficult artworks often make us question whether they are indeed art and, if so, on what basis. Difficult works can also make us anxious because their interpretive tasks may be too hard to understand. These

[23]Peter Schjeldahl, "The Daemon and Sigmar Polke," in *Sigmar Polke* (San Francisco: San Francisco Museum of Modern Art, 1990), 17.
[24]Schjeldahl, "Daemon," 19.

forms of difficulty-induced anxiety can be productive: they may enable the kind of receptivity to change that many find useful; they may reflect the difficulty of the world or that of the human mind; or they may reveal something about the conditions of art. The anxiety may also extend to the social function of art: In what ways might an art that excludes its public still be useful, great art? And, finally, the anxiety may, as in the case of Polke's work, be the source of significant pleasure.

The discussion of difficulty also raises issues that appear throughout this book. On various levels, and in every chapter, this book has argued that art is more than just the objective presentation of what is aesthetically excellent. Although art is about some familiar qualities that have traditionally been thought of as pointing to aesthetic excellence (such as originality, beauty, and progress), it is also about things that seem a little less clearly tied to aesthetic excellence: anxiety, unfamiliarity, innocence and authenticity, competing interests (both on an insitutional and a personal level), one culture's interaction with other cultures, and the power of the mainstream. Through its very specific examination of (1) the museum, (2) primitivism and Orientalism, (3) outsider art, and (4) difficulty, this book highlights some of the issues central to Western high art.

These issues can result in some fascinating creations, such as the installation depicted on this book's cover. In the winter of 1997/1998, Ann Hamilton installed her work *Matterings* in the Musée d'Art Contemporain in Lyon, France. Hamilton took over a large room in the museum and draped from its ceiling a large (90 by 54 feet) canopy of red-orange silk, which undulated in waves. Puncturing the silk was a large telephone pole, on top of which sat an attendant, wrapping his fist with typewriter ribbon, snipping it off when it became as large as a mitten, and dropping it to the floor, where it joined the other ribbons to form a large pile. On the floor were five male peacocks, exotic and gorgeous, that walked about and punctuated the air with harsh, discordant cries. The sound of their feathers and feet moving over the floor played against the faint sound of an opera singer's lesson.

The issues of this book come together in a difficult artwork such as *Matterings,* all of it set in the museum. But *Matterings* was not just *in* a museum, it was physically part of the museum and it was about the museum. The work took over the museum's architecture, presenting art that gave ambiguous instructions on how it was to be used. As visitors walking through the installation, were we viewers or participants? Were we allowed to speak?

What Hamilton did in this and continues to do in many of her works is embody the anxiety that viewers feel when they are faced with difficult work. The attendant perched on top of the telephone pole served as an embodied metaphor of inarticulateness, presenting a Foucault-like nightmare of language that wasn't getting anywhere, that was inexpressible, and that was in some ways mirrored by the birds—gorgeous, on display, but whose harsh screeching was a sign that they were wild animals that don't interact with people, except, perhaps, to avoid them. Hamilton used the peacocks, then, not to perpetuate Orientalist values but to place them, somewhat enigmatically, into a larger discourse about

language, about knowing, and about the museum. *Matterings,* then, raised questions about how we interact with art—questions that this book has begun to address. Some of the art that we look at will inevitably be difficult and unfamiliar. That unfamiliarity will sometimes lead to productive questions about the artwork, sometimes to anxiety, and sometimes to amazement.

Glossary

Abstract Expressionism A movement in American painting after World War II. Abstract Expressionism emphasized process and materials over product in its attempt to record the vagaries and spontaneity of the human mind. Abstract Expressionist artists radically immersed themselves in human subjectivity and stressed the personal over the social elements of their art.

aesthetic The sense of what is visually or sensually appropriate to a given object or action and its context. The aesthetic is not limited to high-art objects; it is not something that needs to be separated from the world of action.

aesthetic contemplation An activity during which the visual pleasure of an art object or event is enjoyed in a context that is free from the distractions of the world. In aesthetic contemplation, the work of art is separated from the "real" world, and this separation is intended to draw attention to the work's formal properties, to what it *looks* like.

anthropological approach to art An approach to art that de-emphasizes the aesthetic uniqueness of an object or action and, by contrast, emphasizes art's social context. In doing so, such an approach to art attempts to understand a work in terms of its broader relationship to its culture.

avant-garde That group of artists and artworks that deliberately challenges the basic premises of the art and culture of its time, at times challenging the very materials, subject matter, and permanence of art. It may even go so far as to challenge the idea of art itself. Frequently designed to shock the mainstream, avant-garde art often has revolutionary social implications.

canon The *generally* agreed upon, central group of works and artists that people find central to understanding and appreciating art.

complicity A strategy artists employ to make the viewer an accomplice in violating some taboo. Complicity elicits strong emotional responses, such as anger, anxiety, thrill, and/or guilt. Works that generate such responses do not merely present beliefs to be "tried on;" they immerse their (sometimes unwilling) viewers in the consequences of a belief.

convention What is typical or expected in art at a given time or in a given context. A convention can be a subject matter (such as the reclining nude), a way of presenting art (in a frame), or a technique (bronze casting). Conventions can become so ingrained, so much the norm, that they are difficult to *see*.

Cubism An artistic movement of the early twentieth century that fractured the pictorial plane, creating a problematic relationship between surface and depth and between the artwork as a representation of the world and as a thing in itself.

ethnographic approach to art An approach to art that considers an object in light of its social function in the culture from which it is taken.

expressionism A style of art that emphasizes heightened emotions and personal interpretation of subject matter, often through exaggeration and distortion.

faux naive art Work produced by mainstream artists that takes on the look of outsider art. For many of its proponents, faux naive art strips away Western conventions (such as theories of perspective and space) and deals instead with direct experience.

folk art The traditional art of a social group.

formal contemplation The act of looking at a work solely for its formal properties, for what it looks like, rather than what it was originally used for.

formalism An understanding of art that is primarily based on what artworks *look* like, how they are put together, rather than what they were put together for. Formalism argues that a work's form (its color, shape, patterns, textures) is central to understanding and creating art.

German expressionism An early-twentieth-century art movement that sought a heightened emotional response to and personal interpretation of its subject matter.

heroic painting A form of art that, in its large scale and typical subject matter, creates art that is designed for large public spaces and that implicitly creates a sense of grandeur for its subject matter.

high art A Western concept of art that is often distinguished from popular or low art. Works of high art were usually thought to be most effectively seen in a context that eliminates normal, daily concerns, a context that enables one to concentrate on a work primarily for its formal values.

iconography The system of signs of representation in which a given art work participates.

impressionism A mid- to late-nineteenth-century movement in art that attempted to create the illusion of a personal experience of the moment, the fleeting, the temporary. The impressionists painted directly from nature with a particular interest in the changing effects of light.

installation art Art that is site sensitive or specific, usually requiring some audience participation with or movement through it.

irony A mode of art that presents a slippage, an unsettling tension between what a work appears to mean and what it could mean. Many artists have found irony useful for the manner in which it undermines stable meaning.

kitsch In its widest definition, kitsch is understood to be an object that is in bad taste, often mass-produced, cheap, and sentimental. For some, kitsch can also be thought of as an attitude not just to art but to politics and other forms of human social behavior.

mimesis The attempt to accurately reflect or imitate an aspect of reality. Such a reflection can be of the external appearance of reality or (increasingly in the twentieth century) of internal psychological states.

modernism An aesthetic and philosophical movement that began in the second half of the nineteenth century. Modernist artists believed that twentieth-century culture was in crisis on a number of levels, from religion, to politics, to the rise of mass culture and urban life. In response to this crisis, modernists explored the implications of the decline of old systems of explaining and organizing human behavior and turned to new forms of organization, such as Freudian psychology, anthropology, or Marxism.

naive art Art that, being produced by a person with no special training in art, unintentionally violates the conventions of mainstream or high art.

Orientalism A Western way of thinking about Eastern cultures that developed in nineteenth-century Europe. Impossible to disentangle from the West's economic and cultural domination of Asian, Near Eastern, and North African cultures, Orientalism depicts the Middle East and Asia as exotic, sexualized places, radically different from the West.

Other A person or group of persons that is seen as radically different from a perceiving, dominant group—a group that feels both powerful and threatened by this other person or group. Seeing the Other as *completely* different from it, the dominant group either ennobles or debases the Other. Because the Other is radically different, it produces in the dominant group a crisis that must be responded to, understood, perhaps even domesticated.

outsider art Art made by a person who is *outside* of Western culture in a crucial way (because of education, economic status, or health) and who produces art that on several levels works in ignorance of Western high-art conventions. Many critics believe that the isolation of the outsider artist allows innocence to exist, an innocence that has been lost by people in the mainstream.

pattern and decoration movement A 1970s art movement that created work that was intentionally decorative.

performance art Intentionally provocative, staged events that are often ephemeral and have an implied narrative that uses many of the conventions of the theatre.

pop art A movement of the late 1950s and 60s that used images and attitudes from popular culture as the subject matter of art.

postimpressionism A general category that describes various art movements and art after nineteenth-century impressionism, such as that of van Gogh and Cézanne.

postmodernism A philosophic and aesthetic movement that opposes itself to high modernism in several key areas. Seeing modernism as a movement that implicitly believed in "grand narratives" (any single system that could explain the world, such as mythology and religion), postmodernism is skeptical about ultimate values.

primitivism In modern art, the representation of tribal cultures as composed either of noble innocents or of violent and sexually threatening peoples. Tribal culture is represented as an Other—as opposed to Western culture, which is seen as being both rational and corrupt.

Romanticism A nineteenth-century aesthetic and philosophic movement that stressed originality and the creating force of the imagination and highlights the importance and uniqueness of the creating genius.

simulacrum A term from the French theorist Jean Baudrillard, denoting an object or act that has the appearance of simulating the real, but the real that it apparently imitates either doesn't really exist or may exist but the simulacrum has made it redundant or unnecessary. (Disneyland's Magic Kingdom is an example of a simulacrum.) Baudrillard uses this term as a way of understanding much contemporary culture.

site-specific art Art that is designed to be situated in and interact with a single specific location.

social realism Figurative, narrative art, from a Marxist point of view, that is designed to be accessible to the working classes and depict subjects of social concern.

sublime An aesthetic effect of extreme interest and importance for nineteenth-century Romantic artists. The sublime goes beyond the category of the beautiful; it is an experience akin to terror that one feels in the presence of great art or magnificent landscapes.

surrealism A twentieth-century movement in art, influenced by Freudian psychology, that juxtaposes highly charged (but usually unrelated) images as a way of getting access to the subconscious and irrational.

syncretism A reconciling of disparate (and occasionally opposed) systems or cultures into a new, sometimes internally inconsistent system.

Wunderkammer German. Literally, a cabinet of curiosities. A disparate collection of exotic objects from around the world, collected to stimulate learning and to dazzle and amuse.

INDEX